Fairies, Unicorns and Mermaids Coloring Book

This Coloring book belongs to:

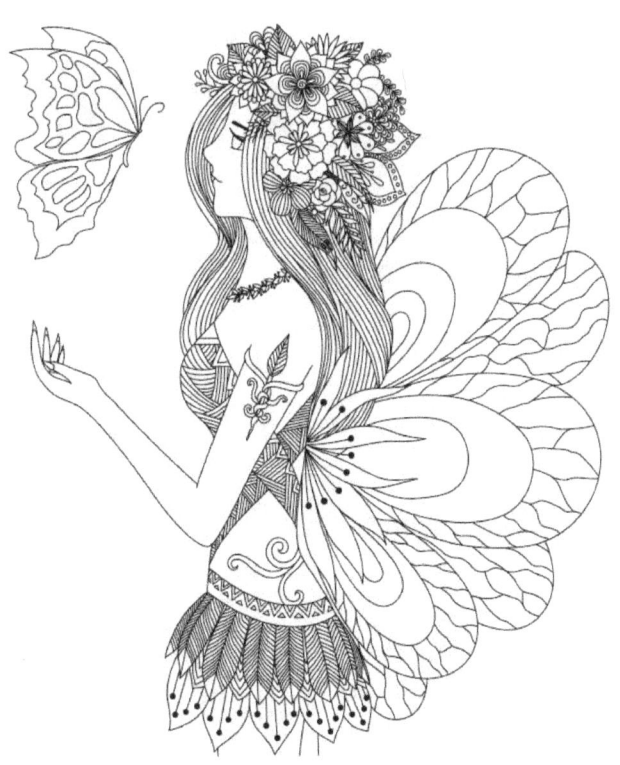

Copyright © 2019 Magical Coloring Books

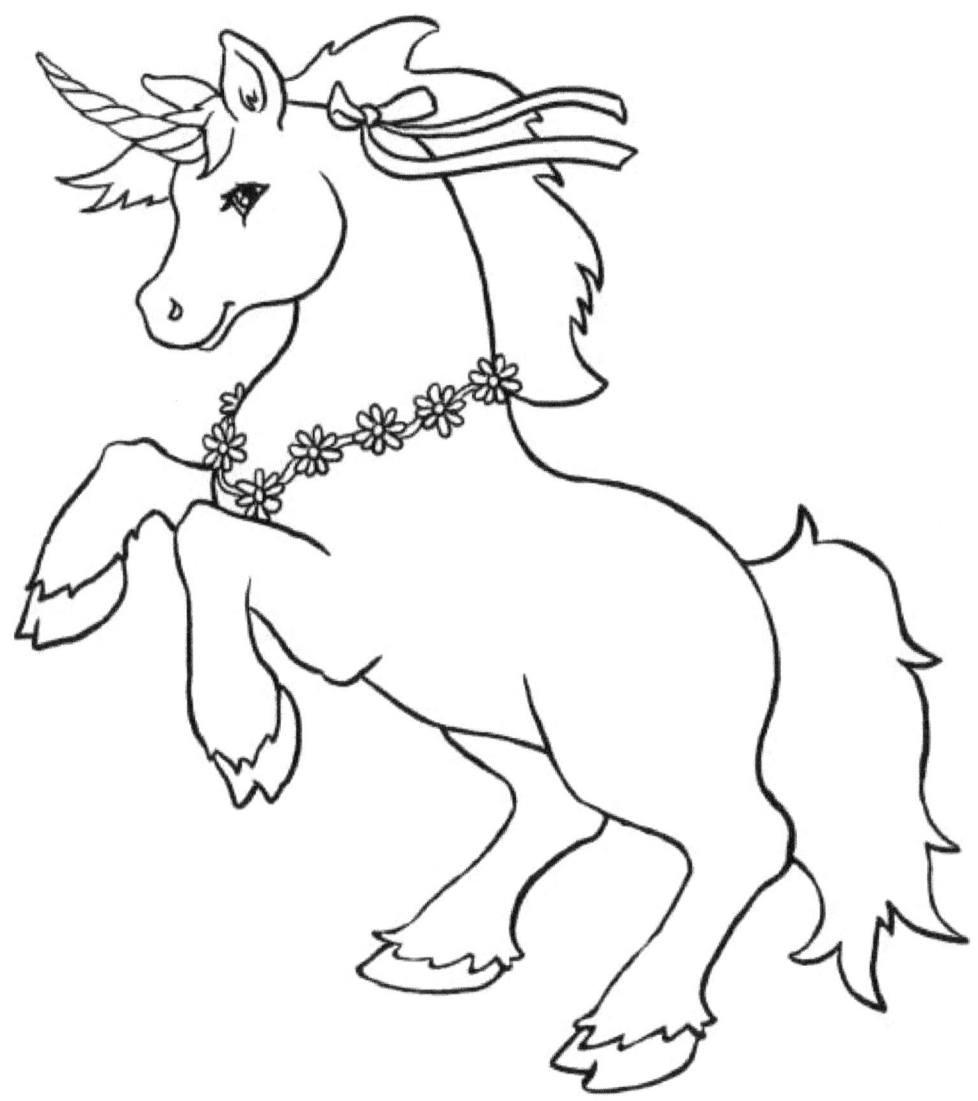

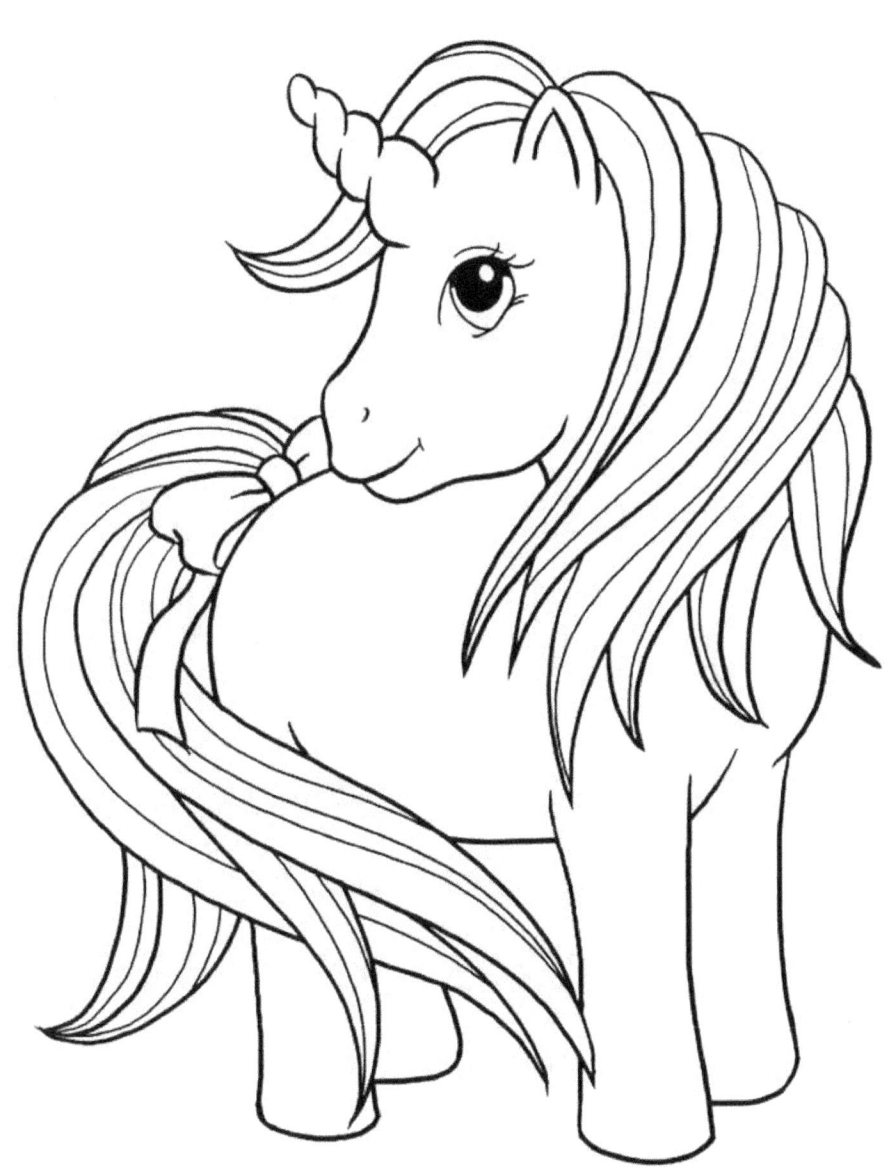

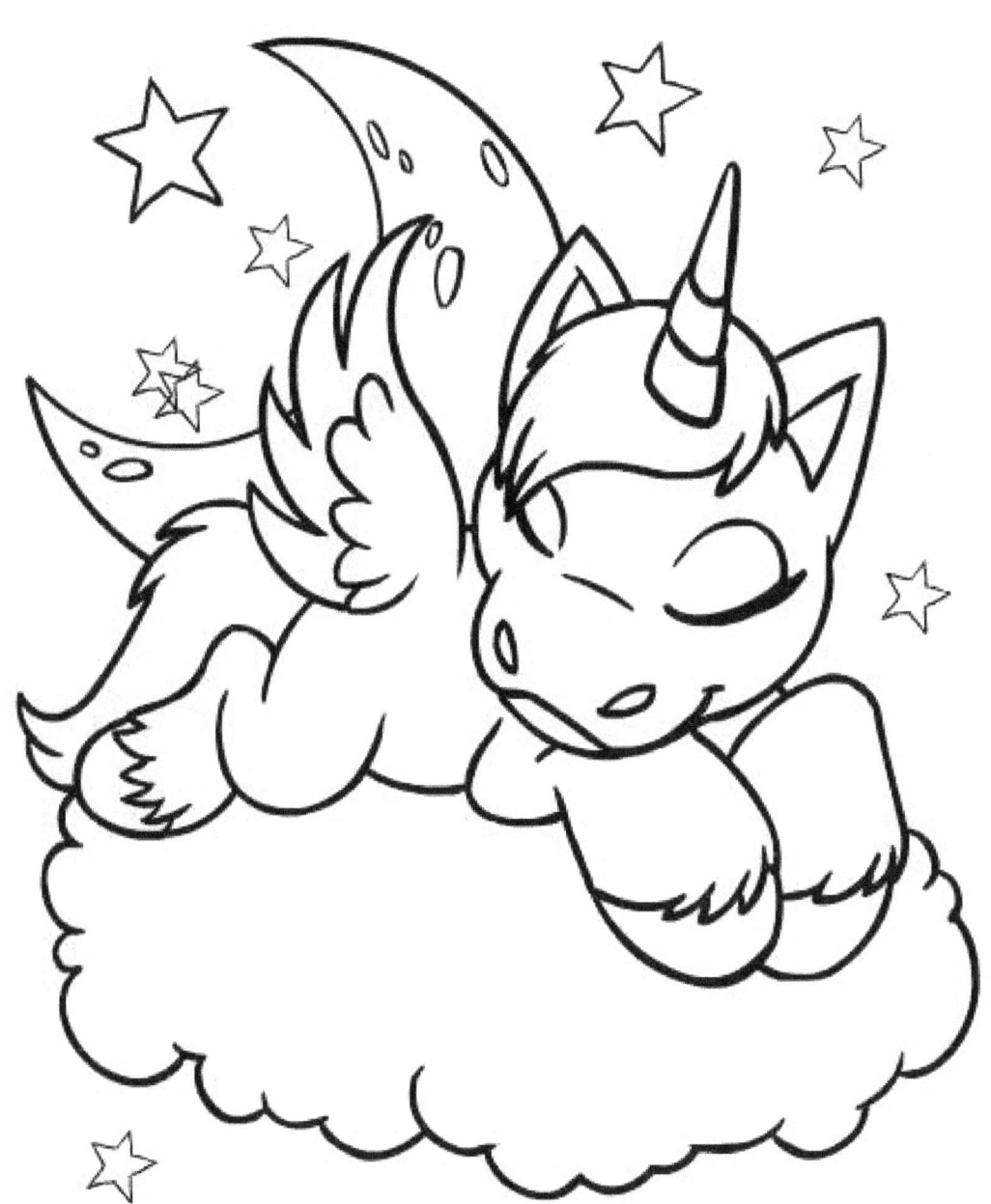

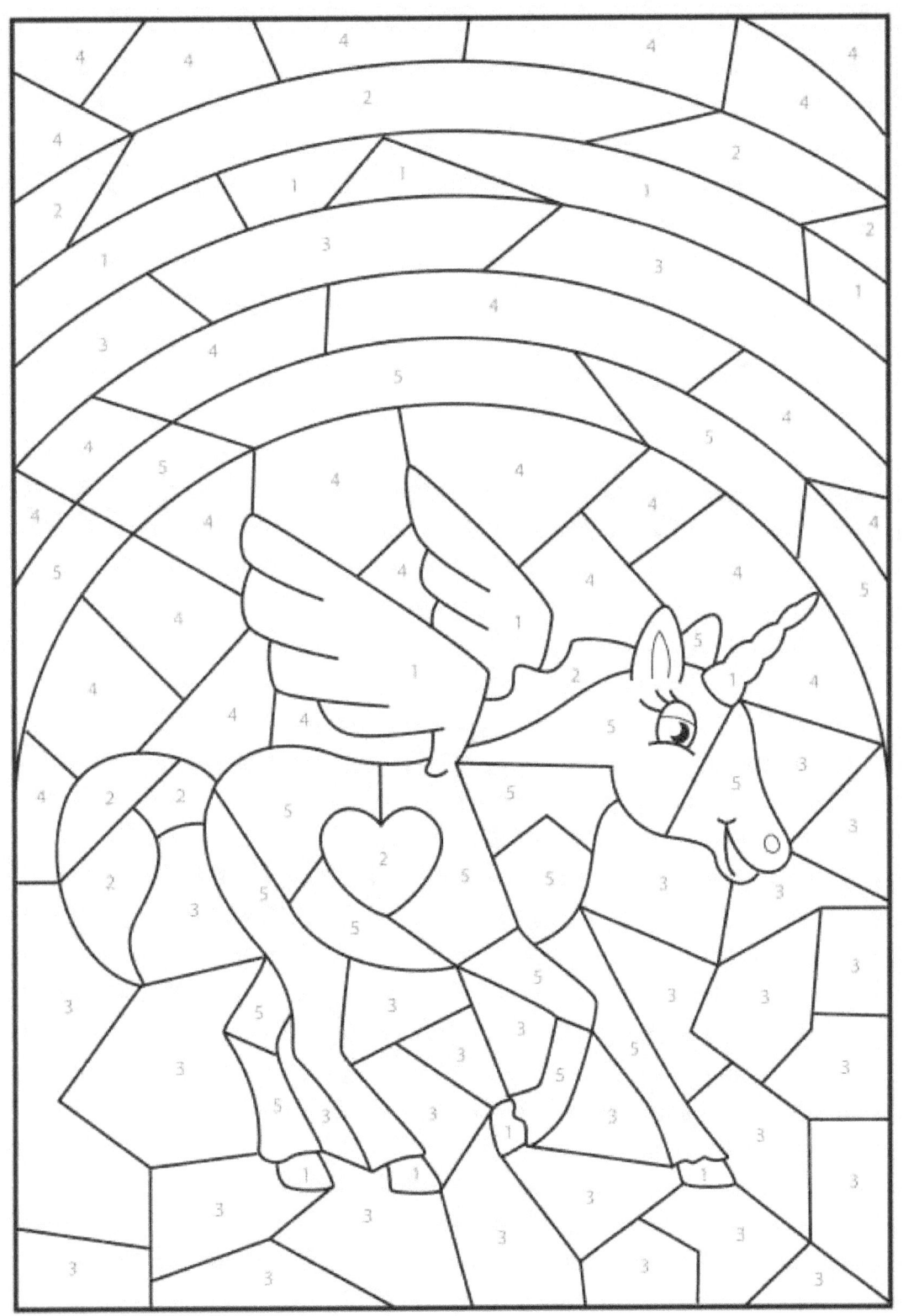

1. Yellow 2. Red 3. Green 4. Light Blue 5. Purple

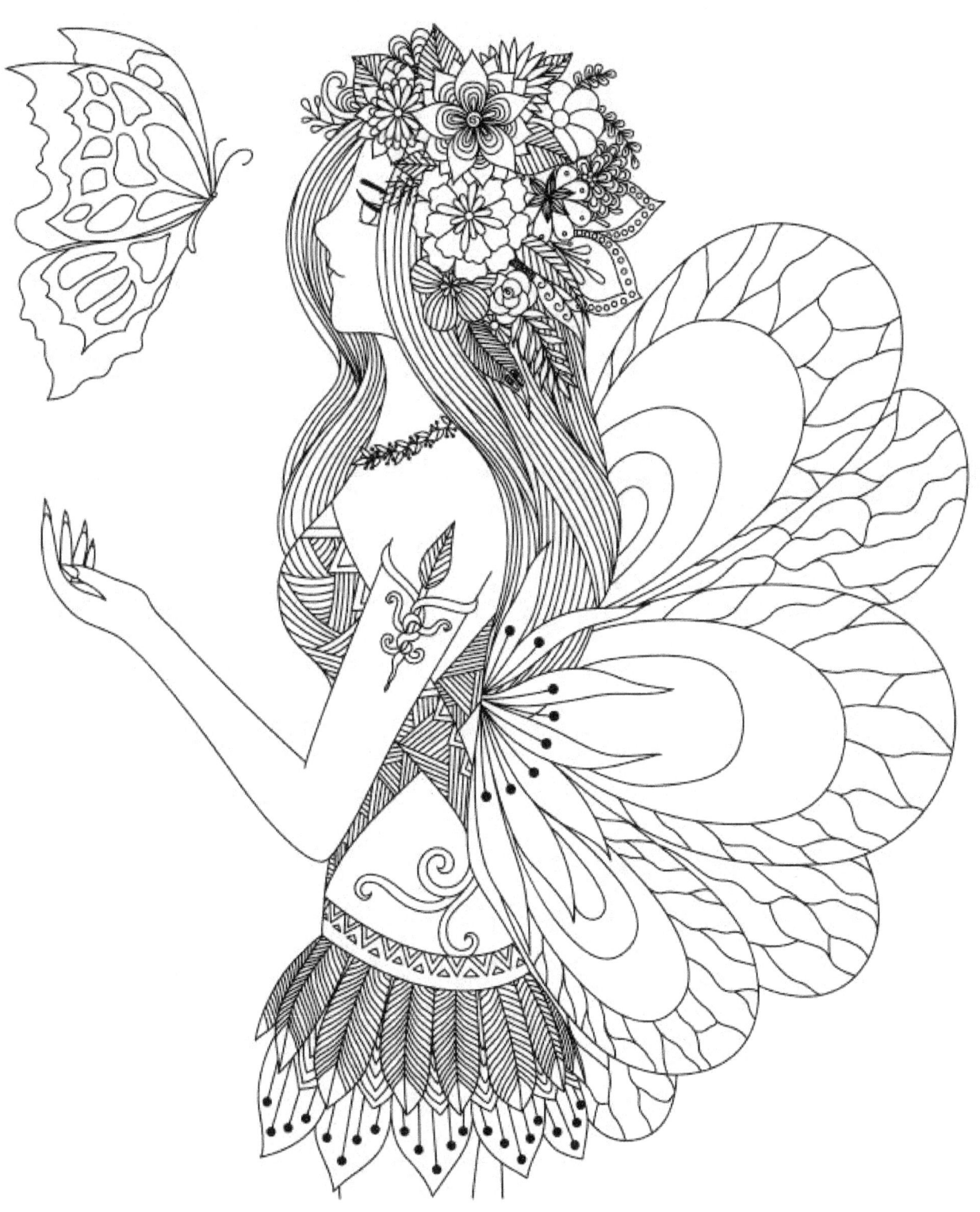

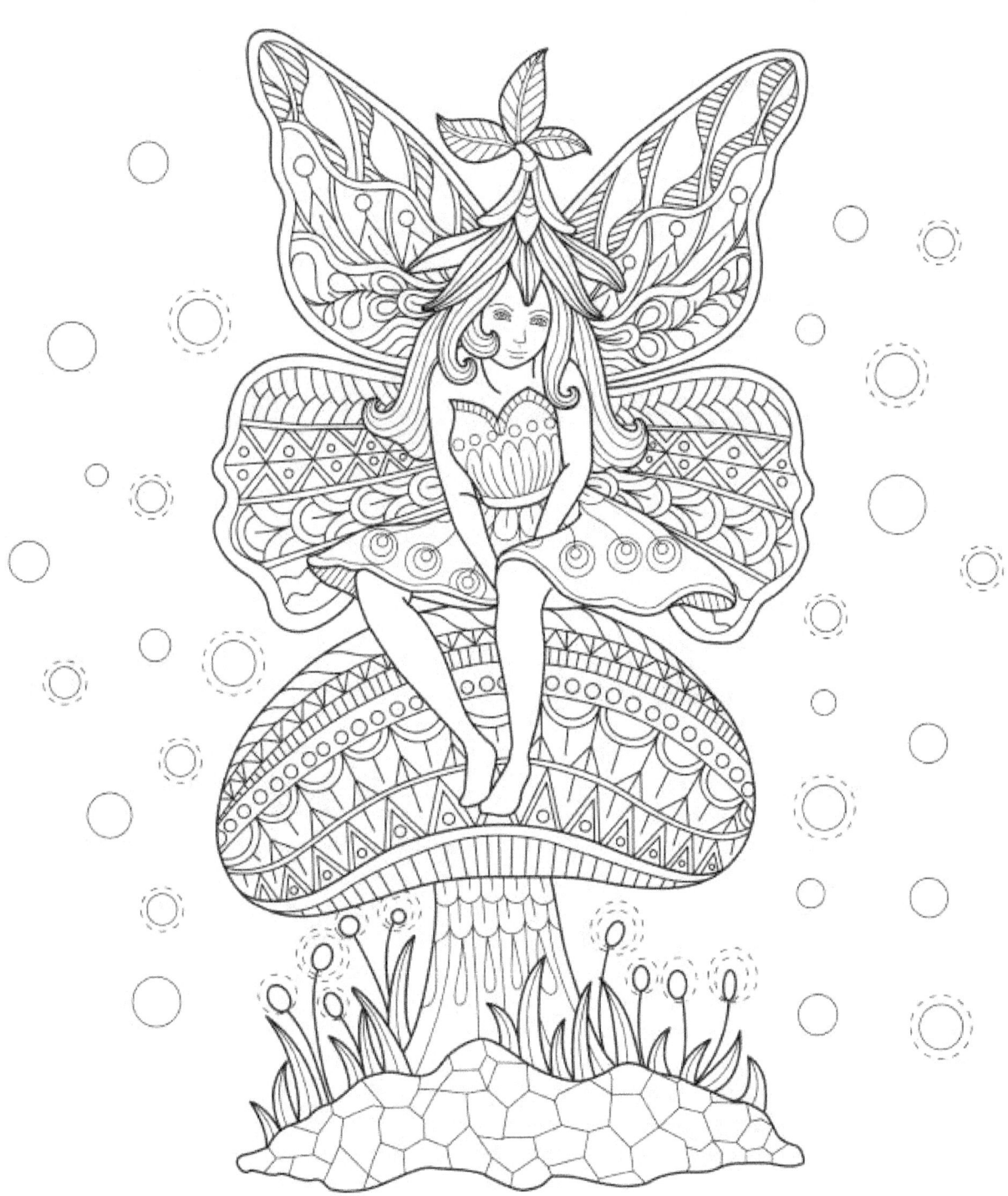

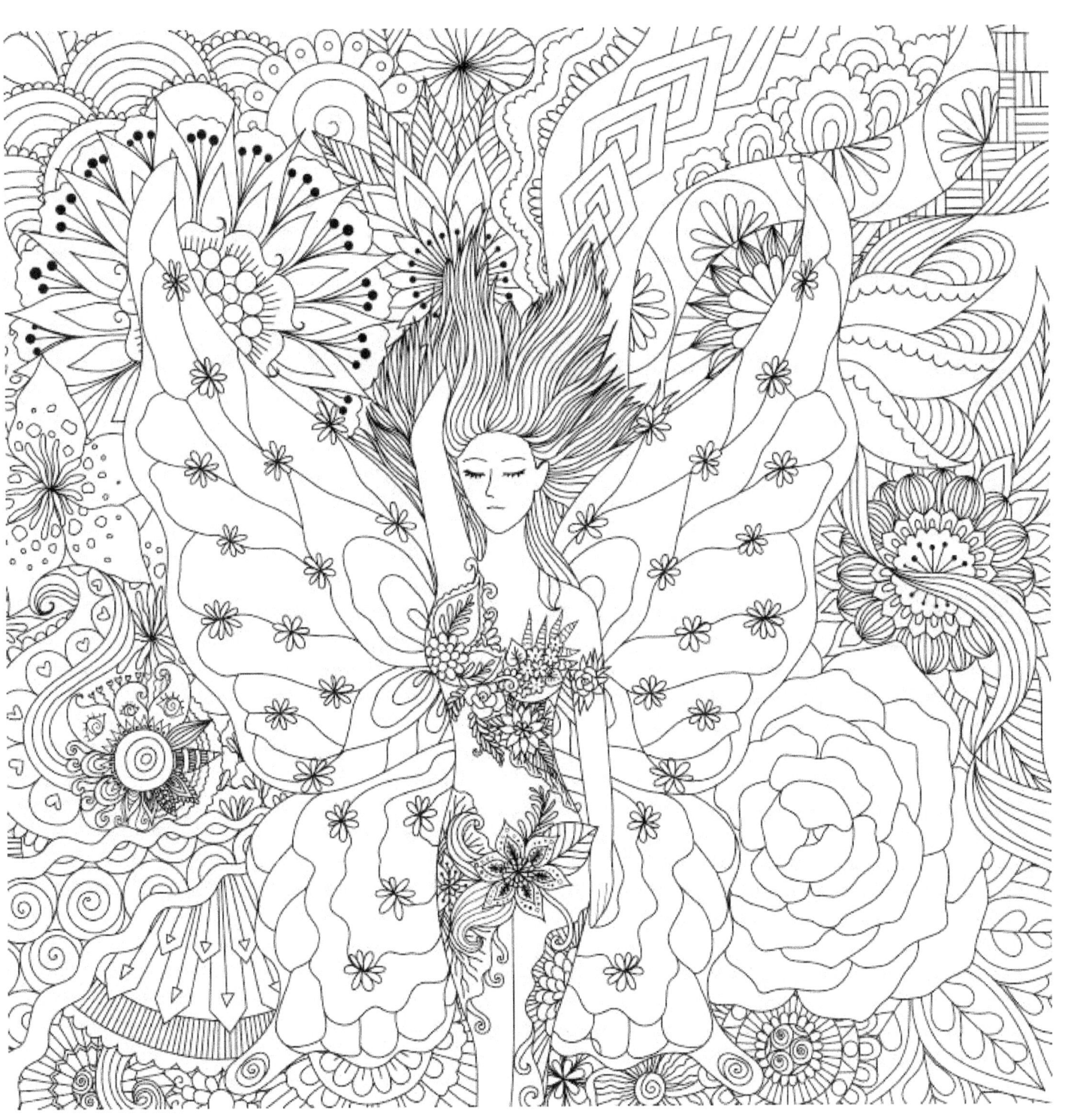

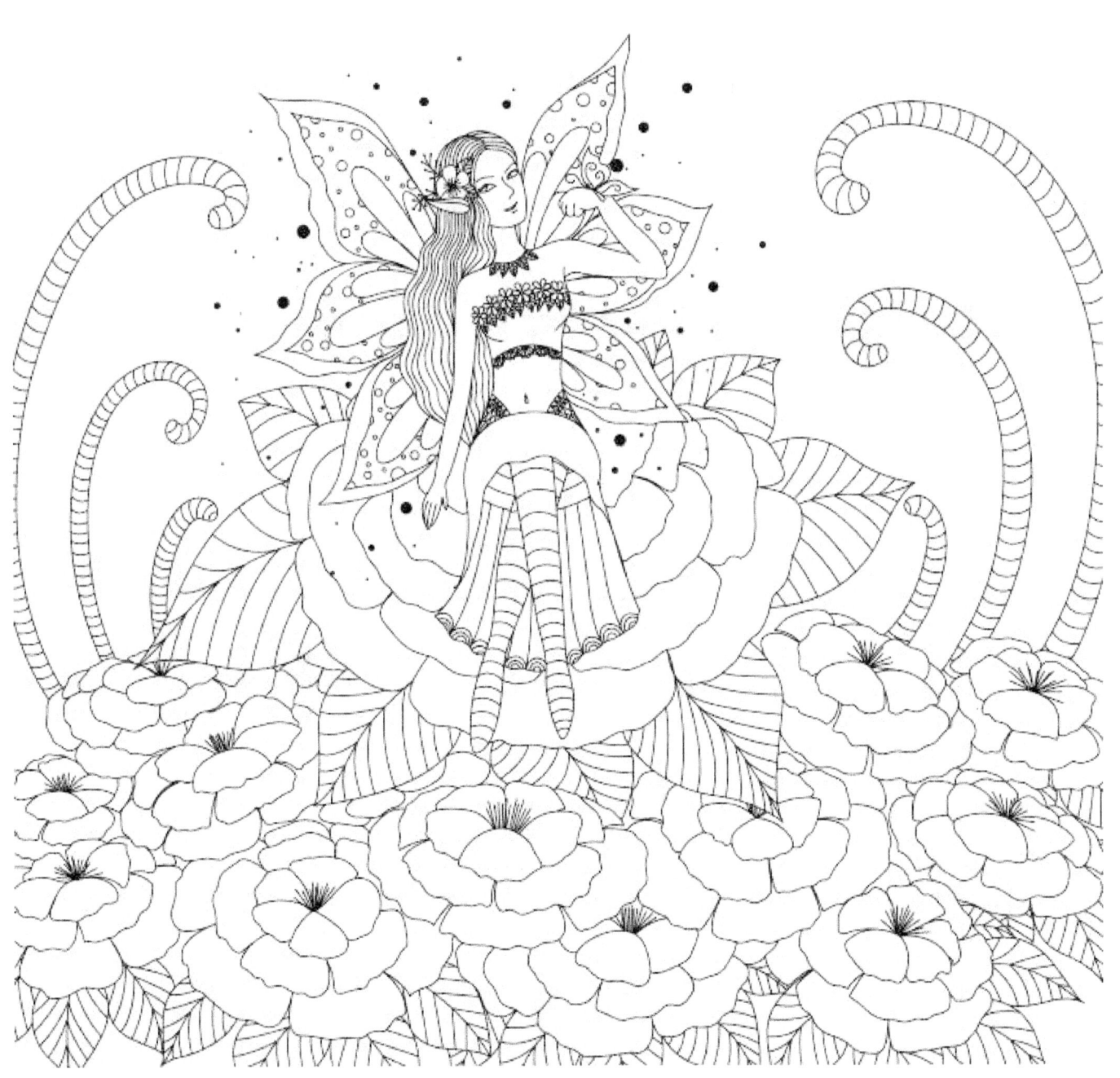

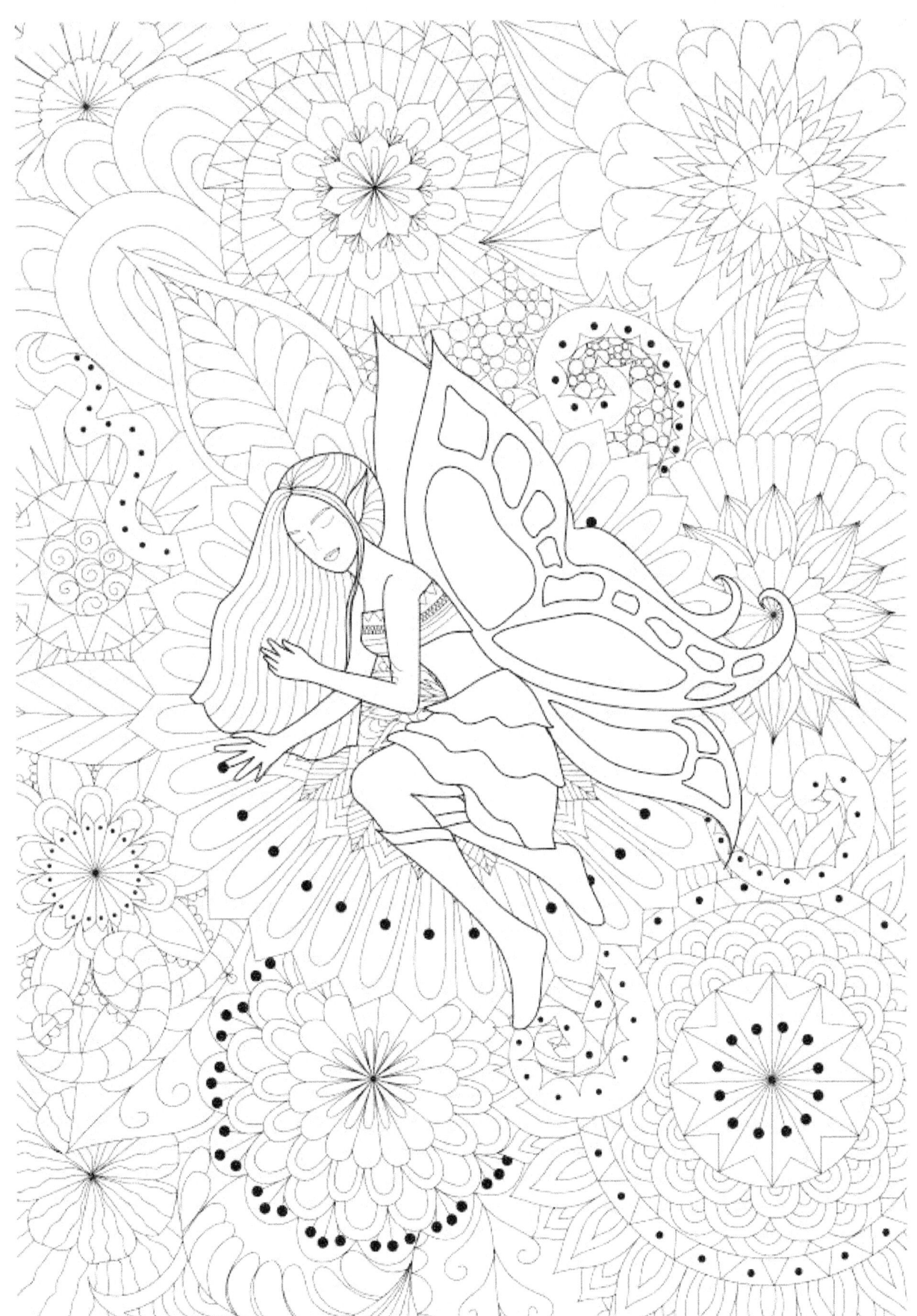

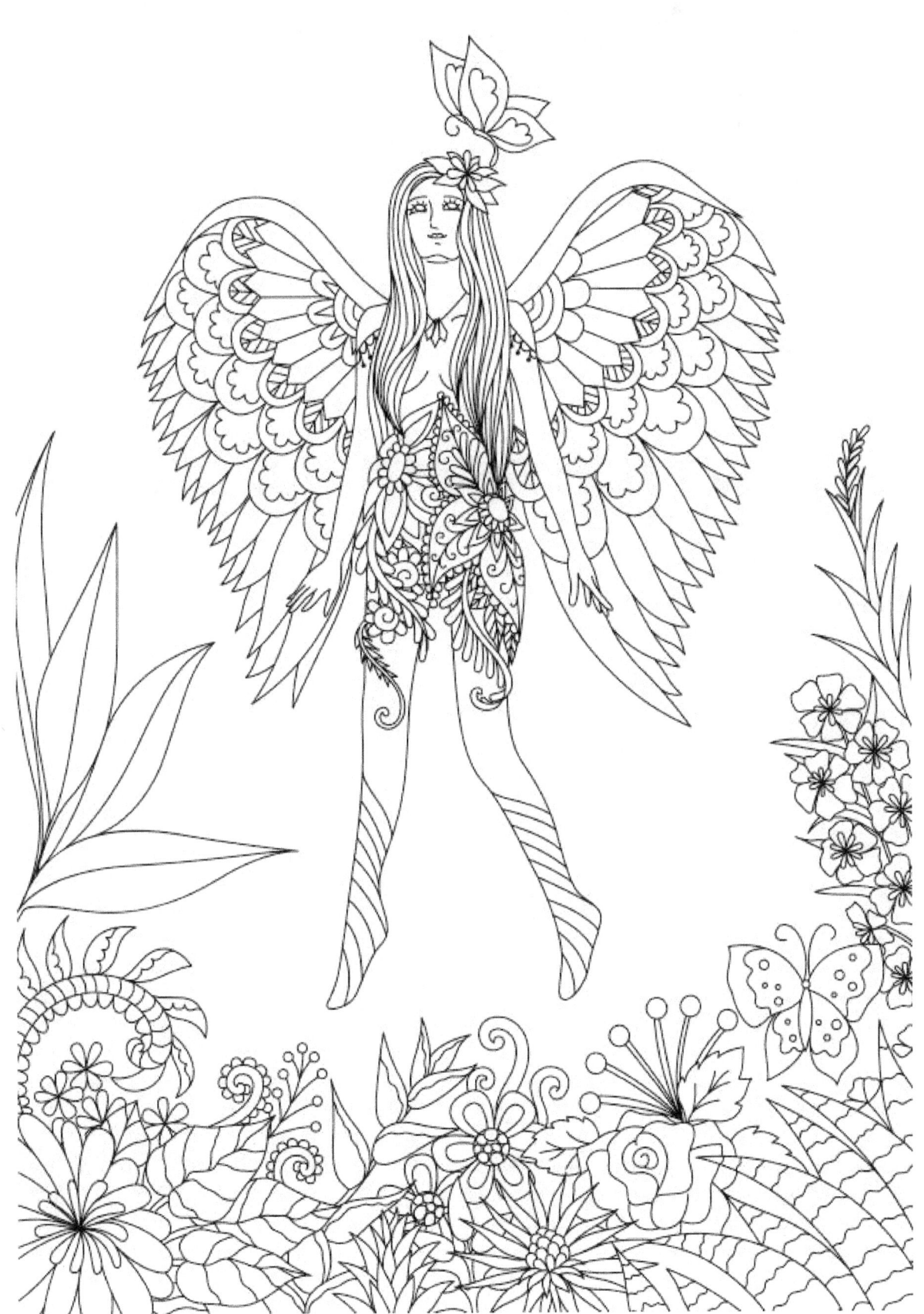

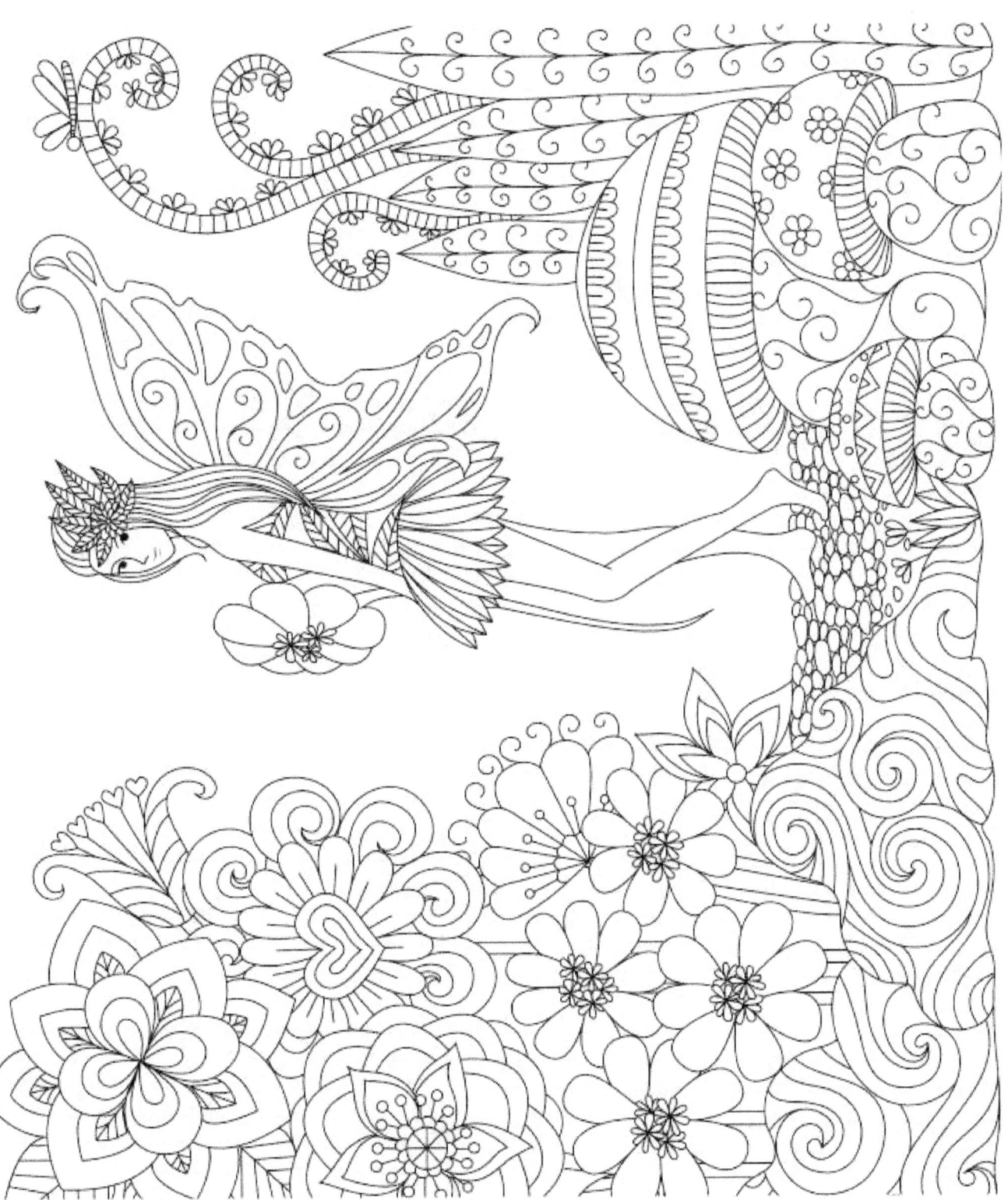

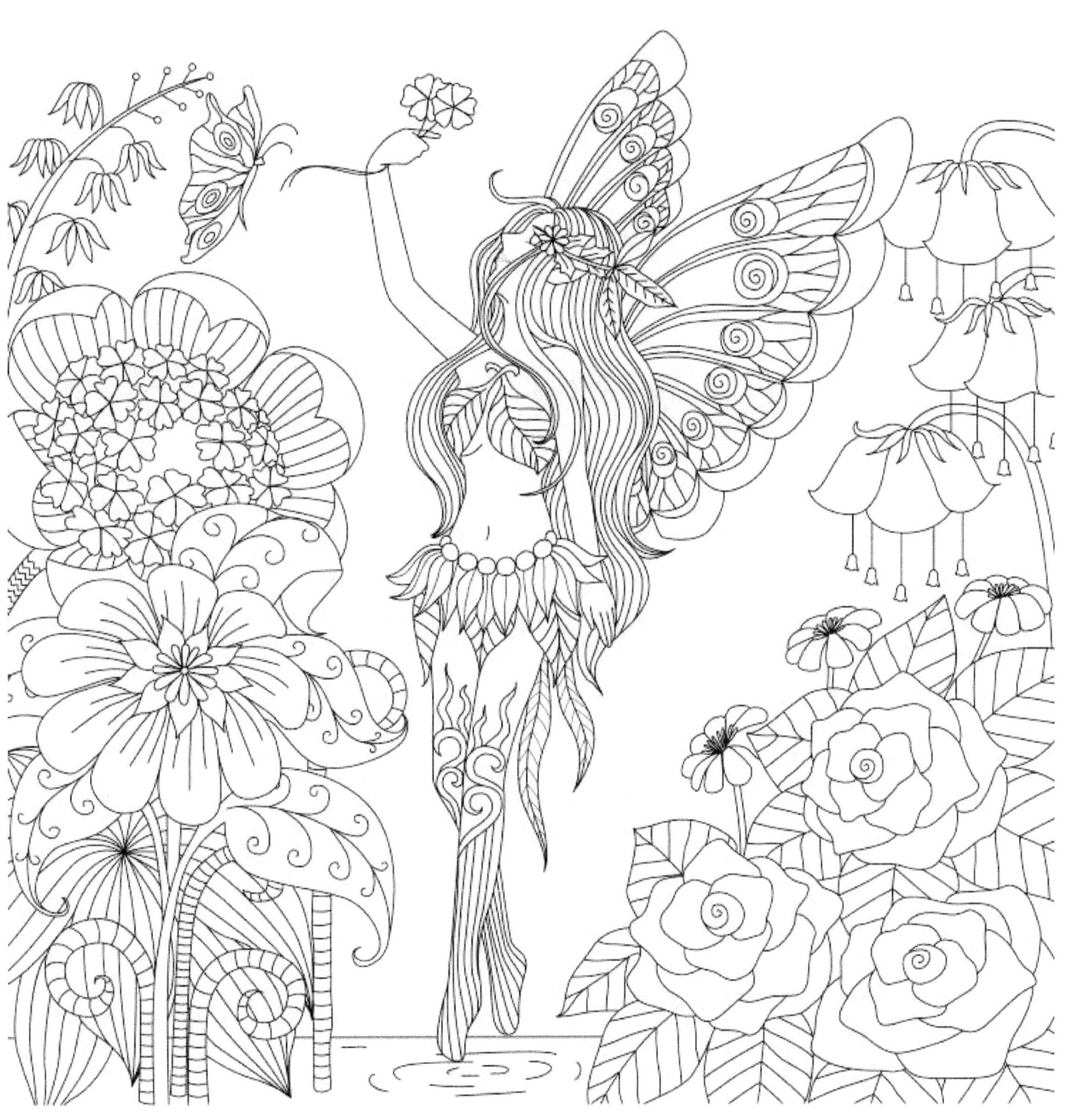

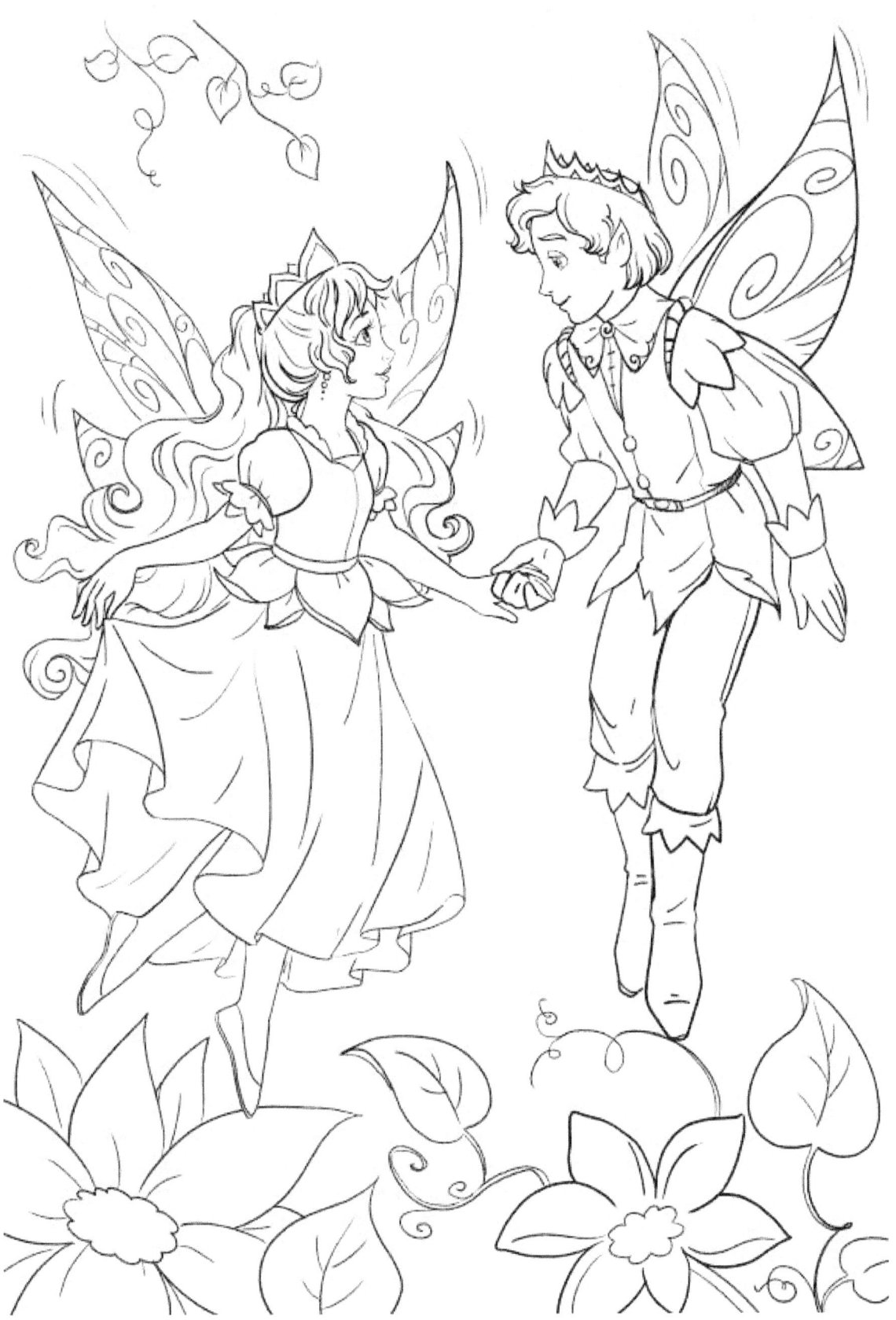

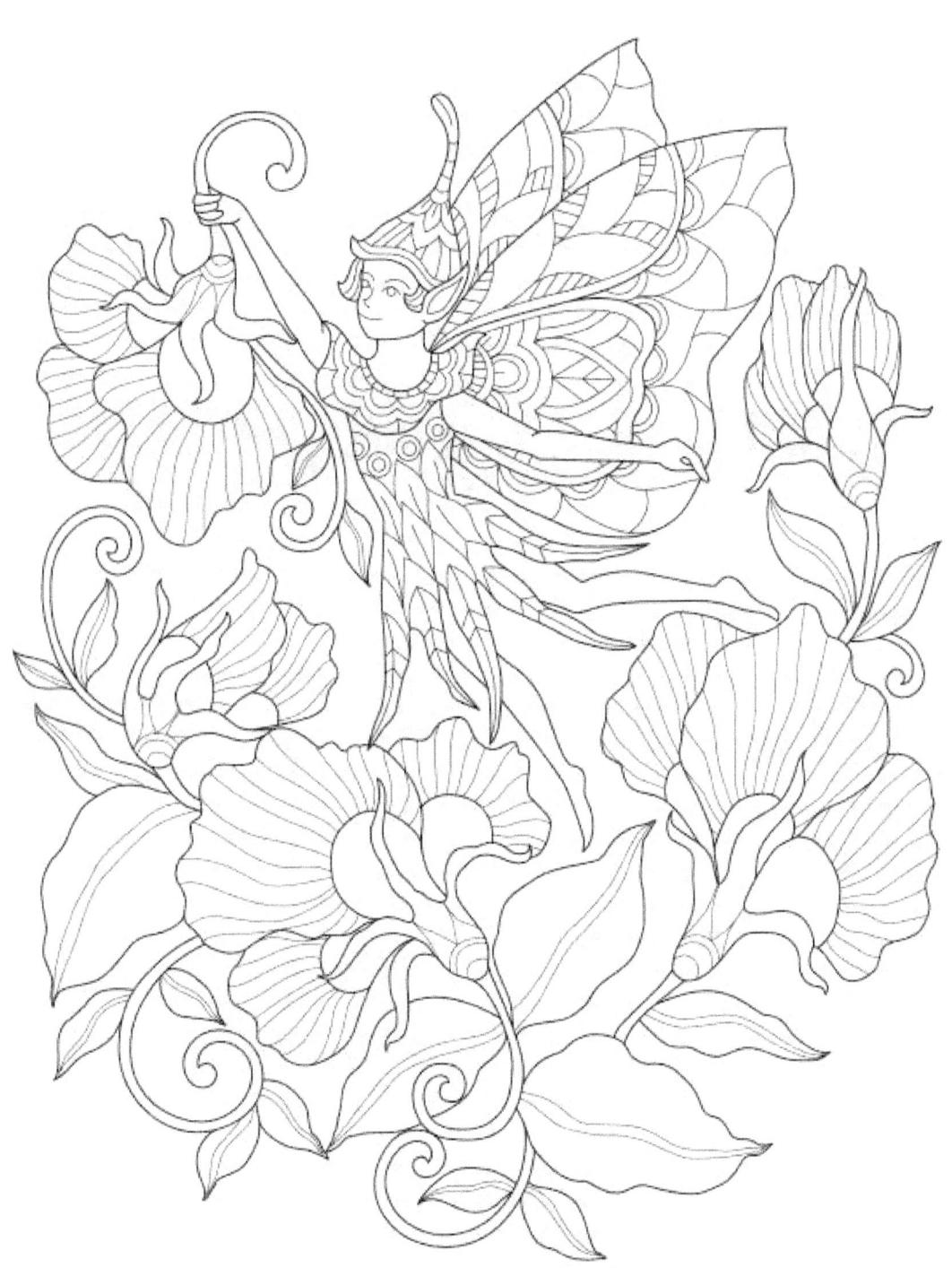

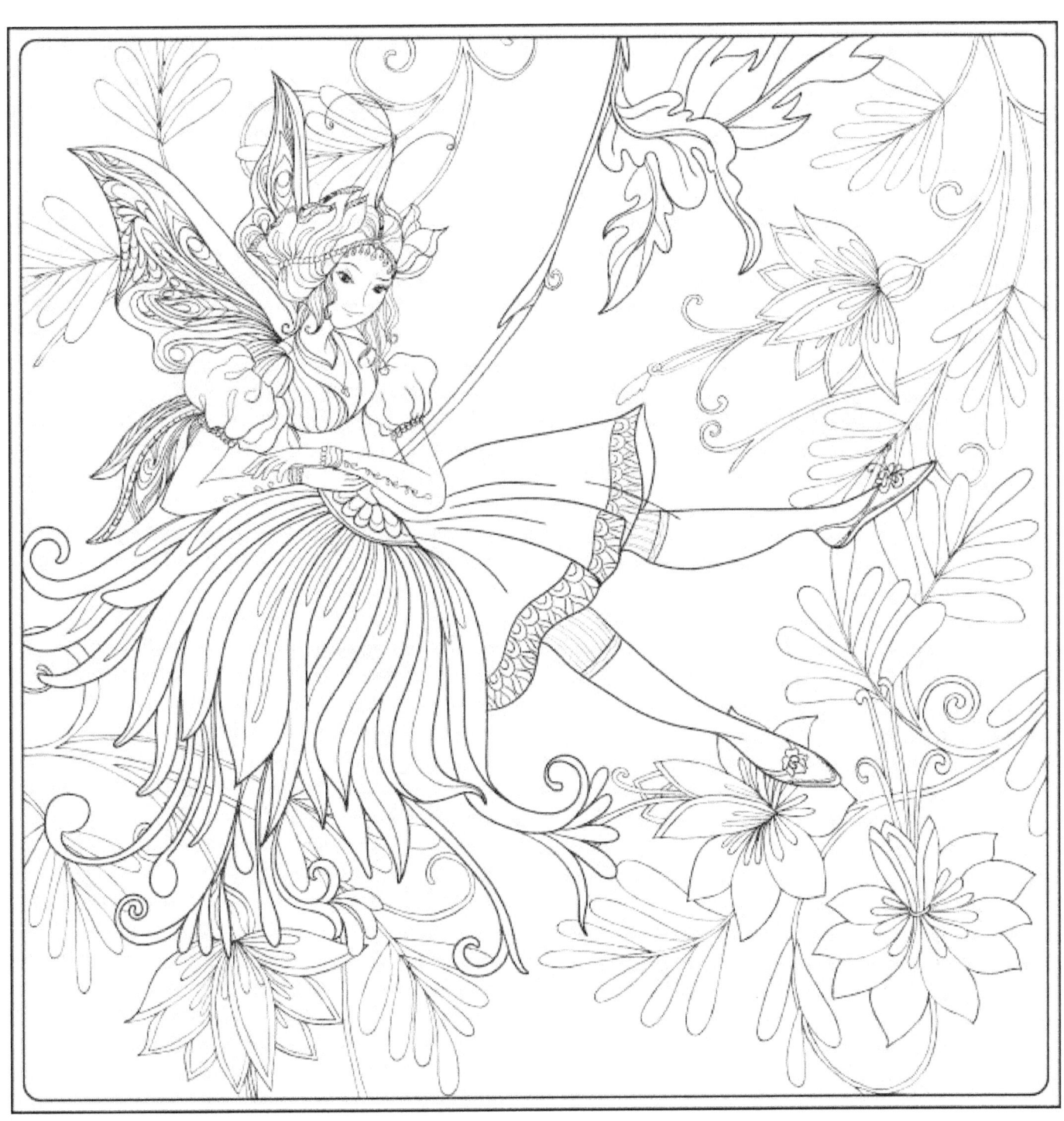

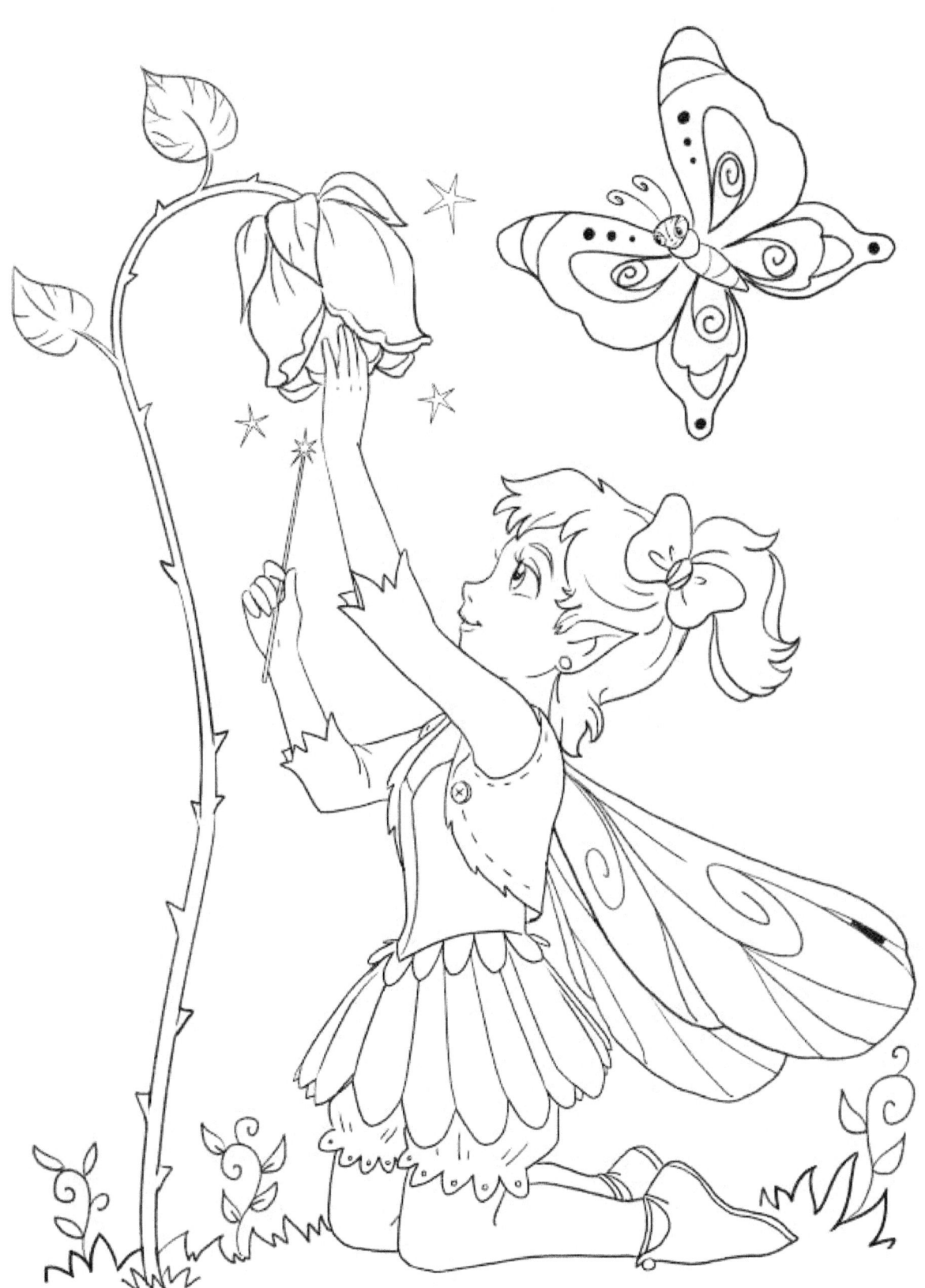

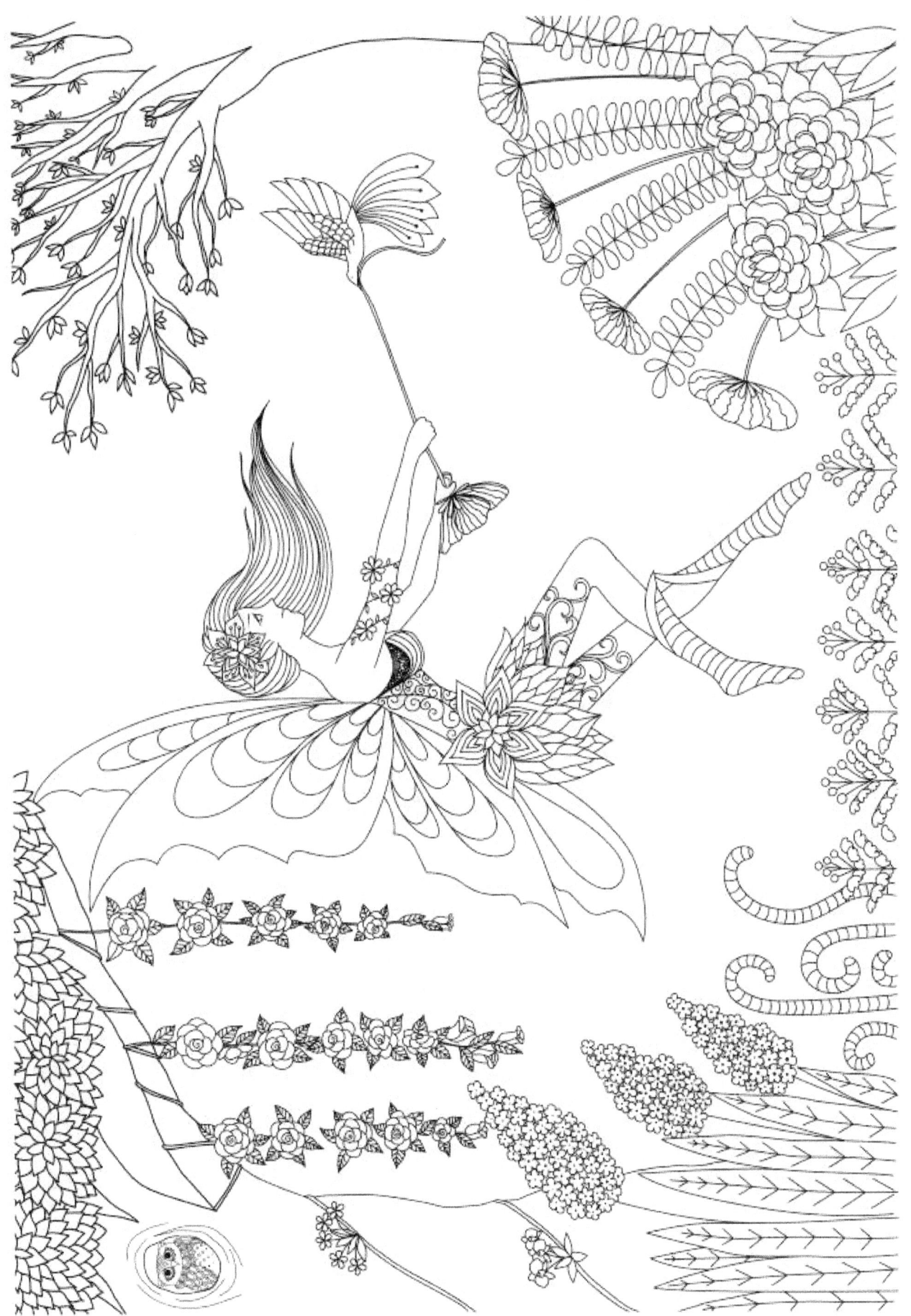

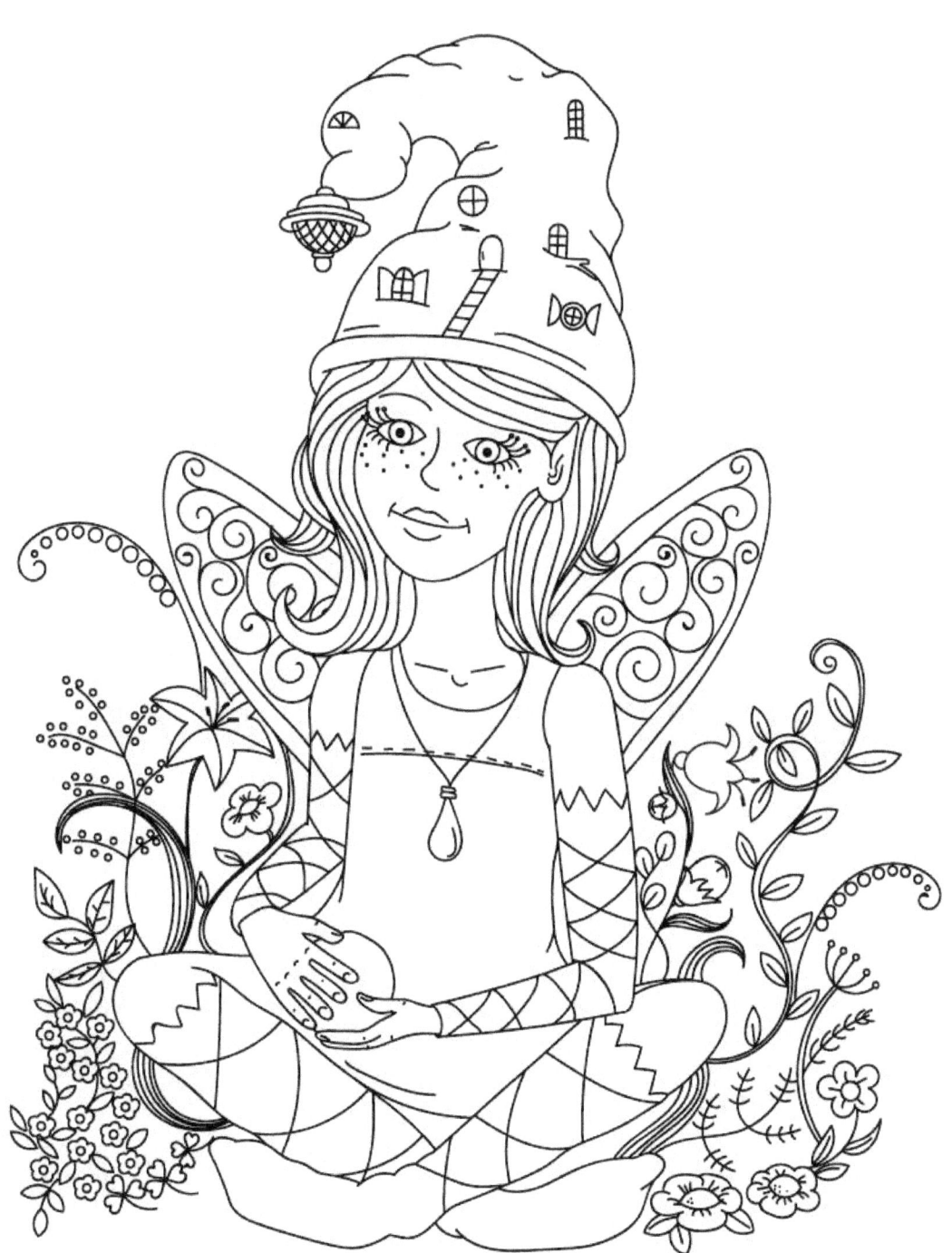

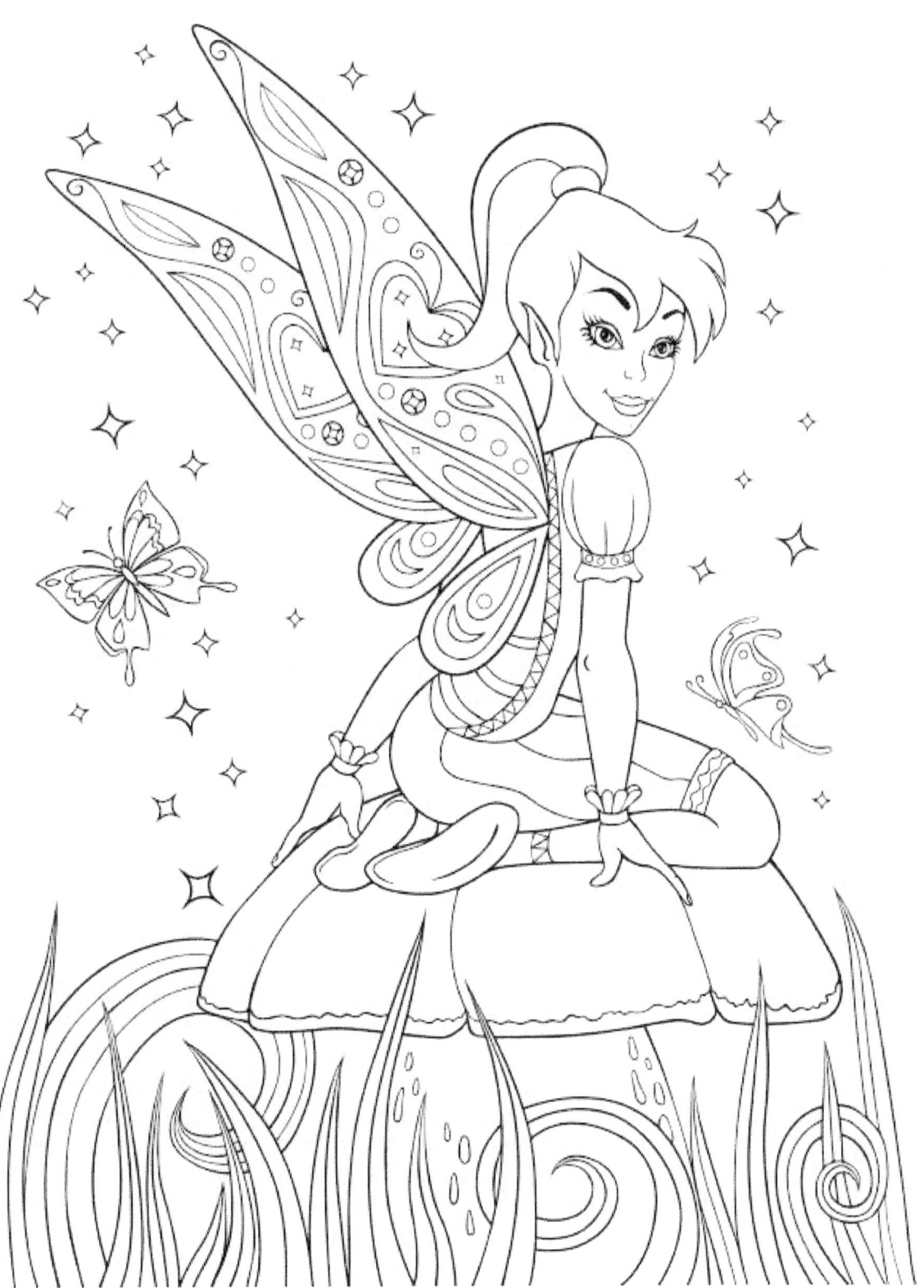

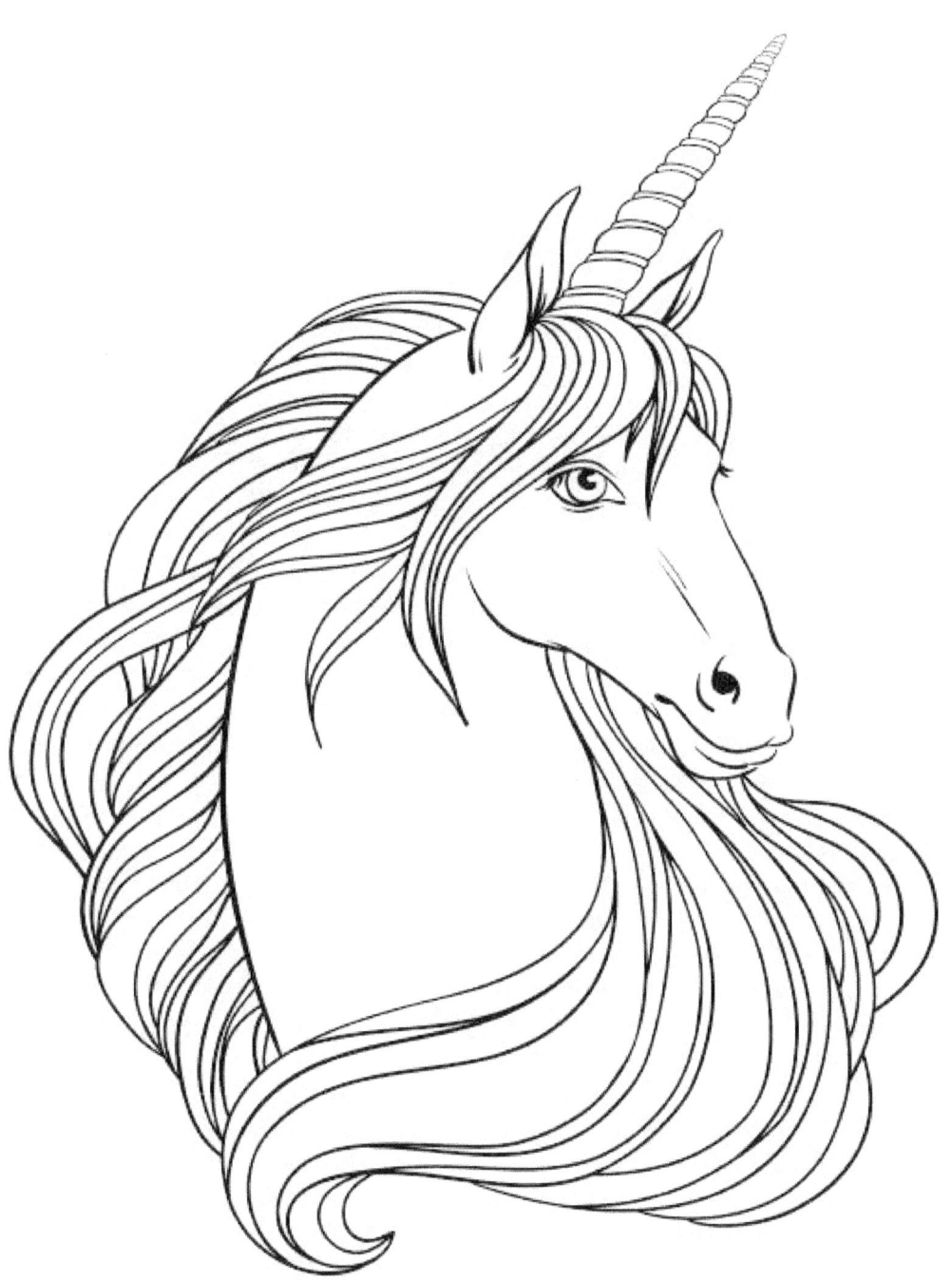

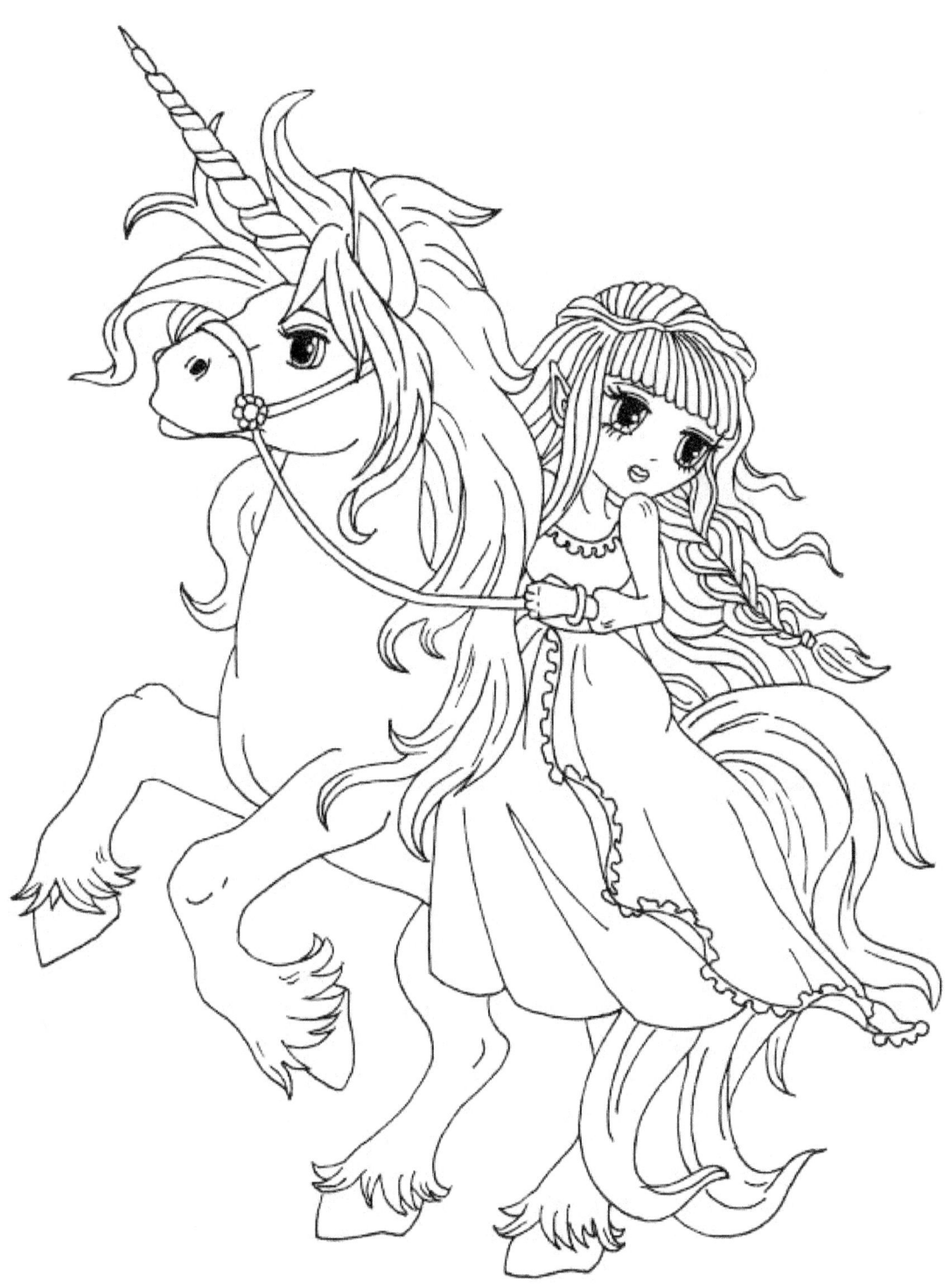

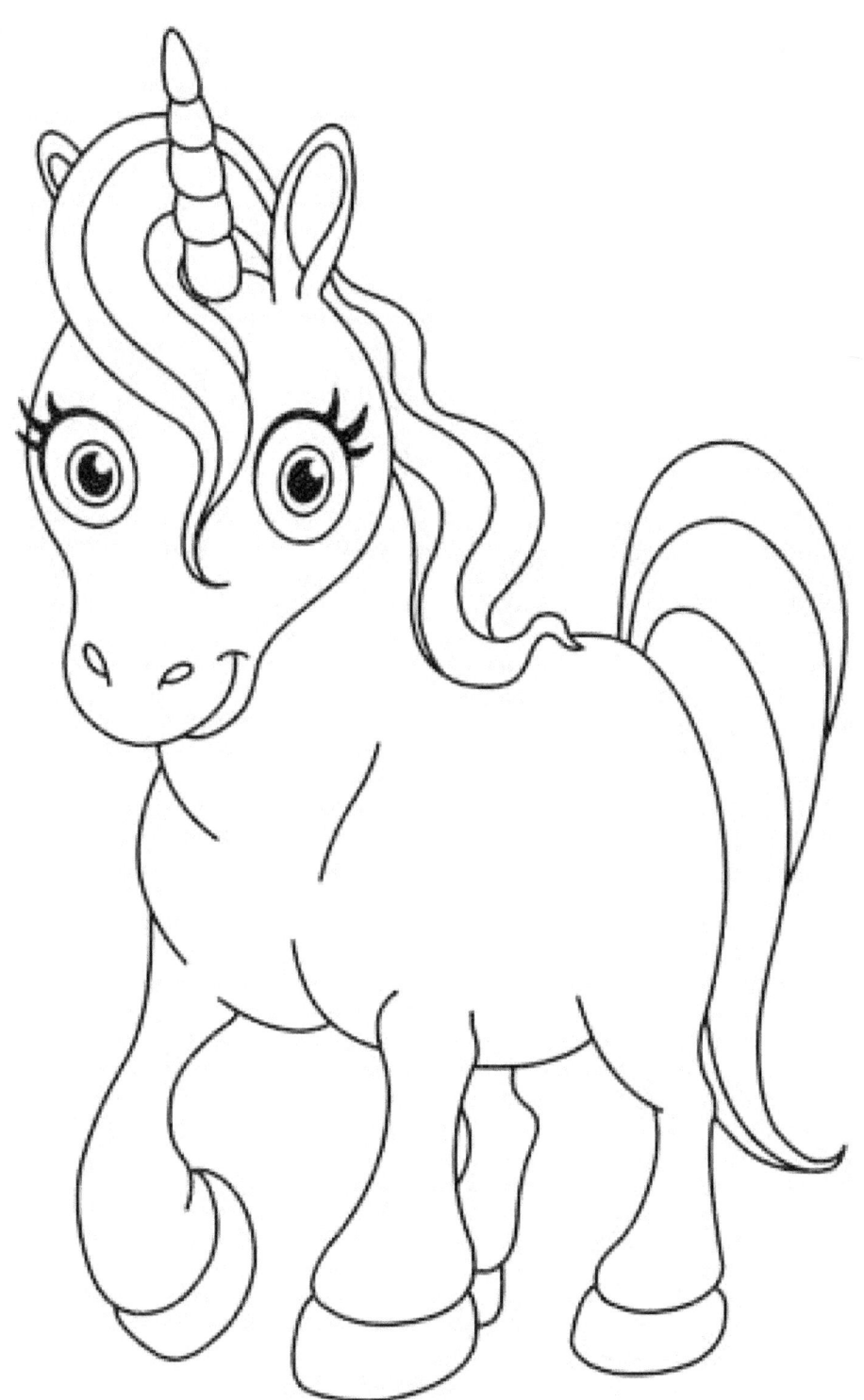

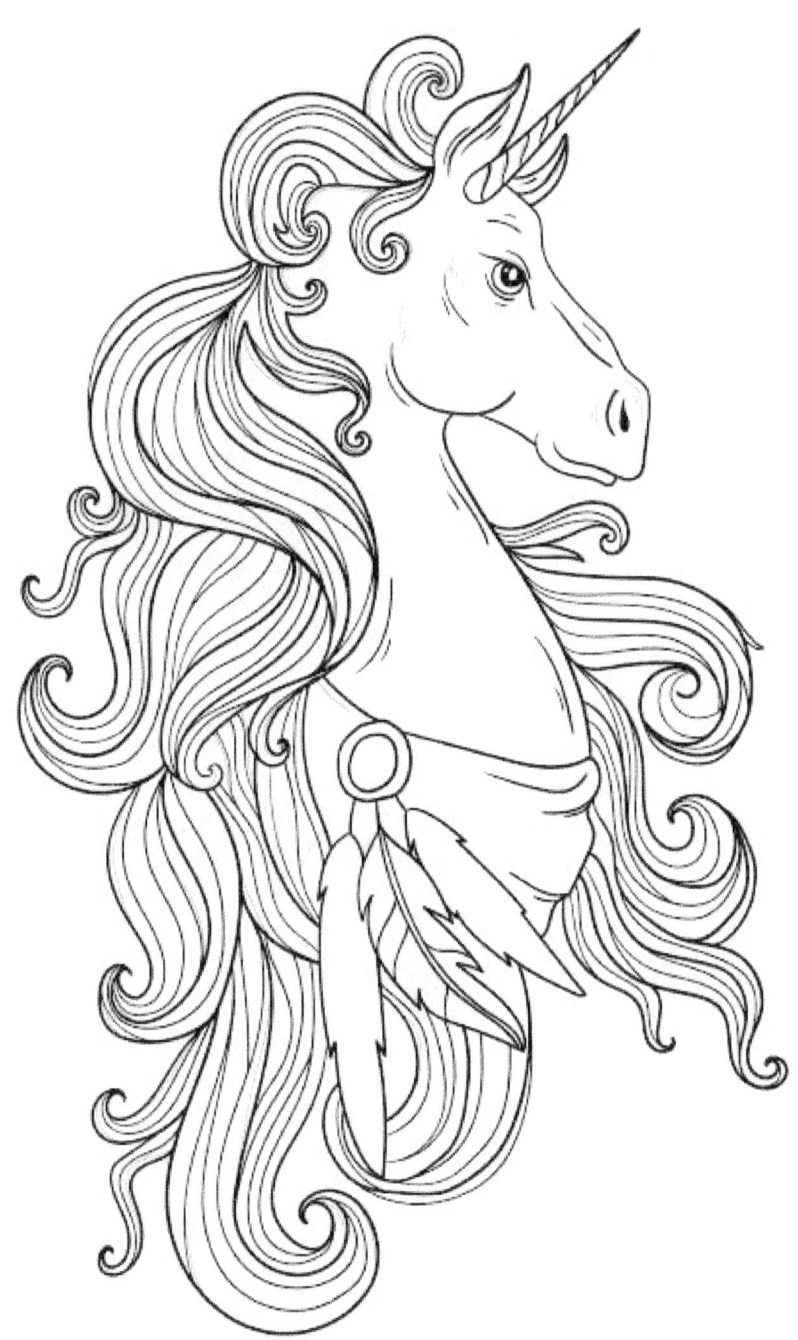

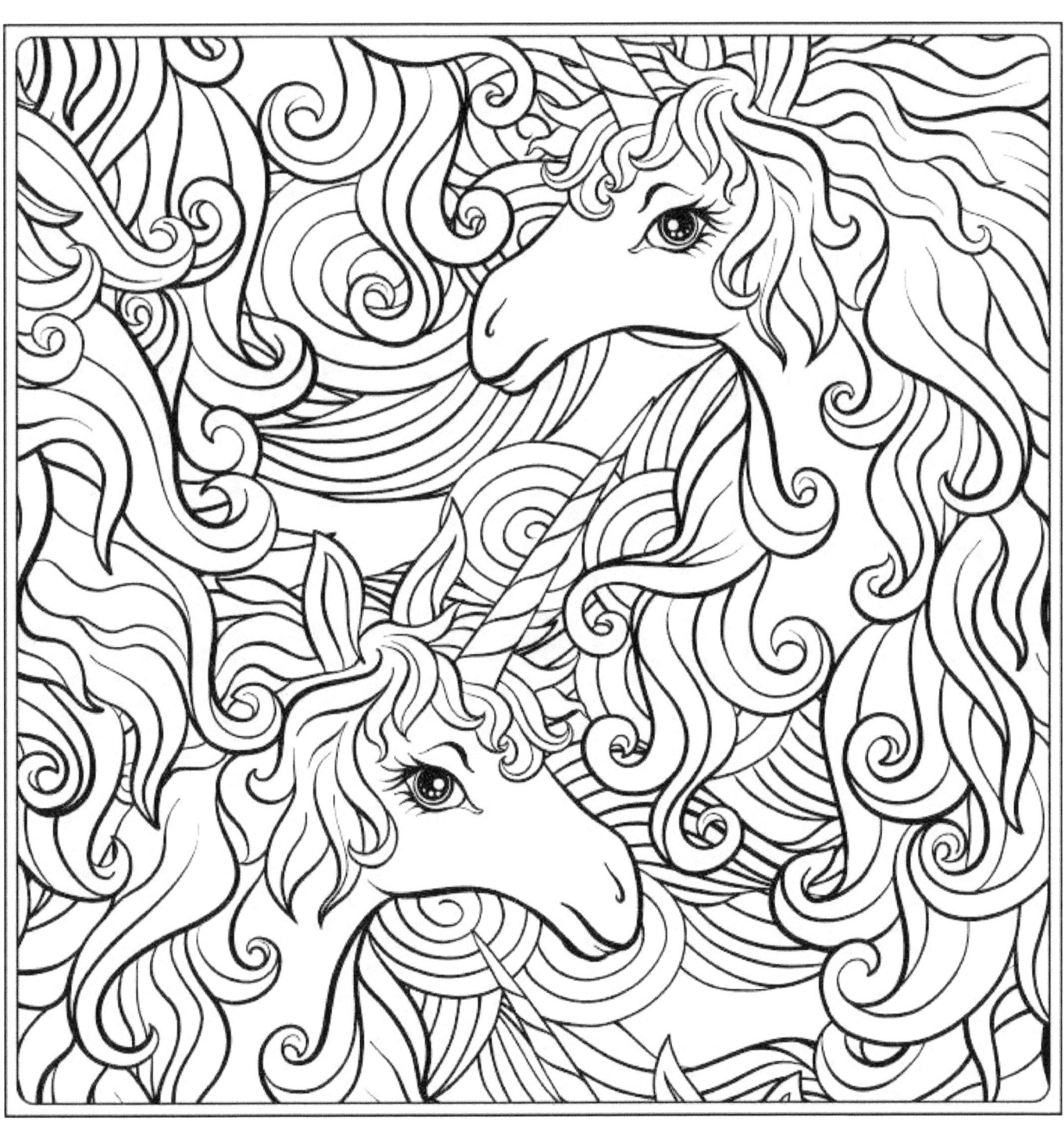

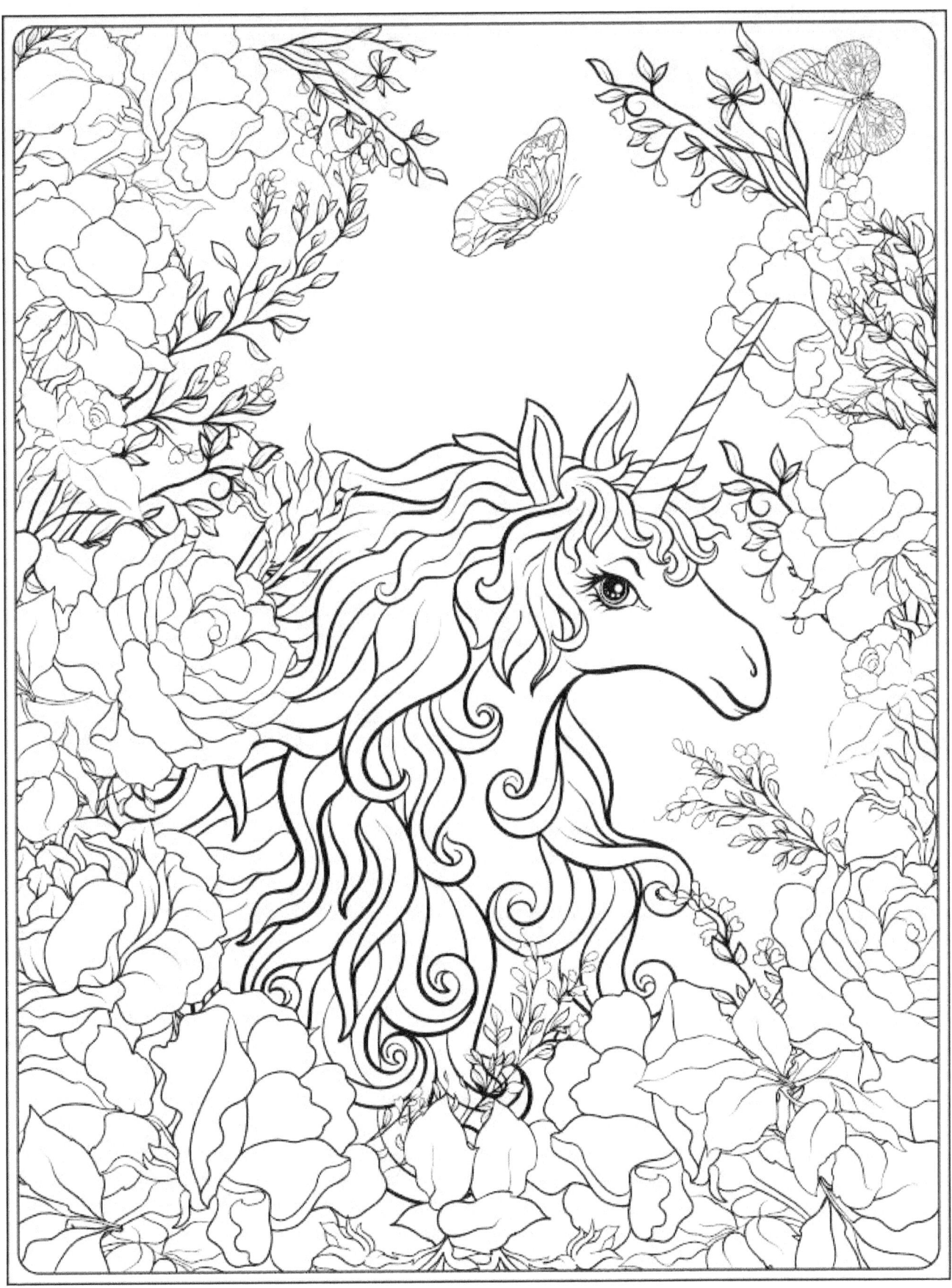

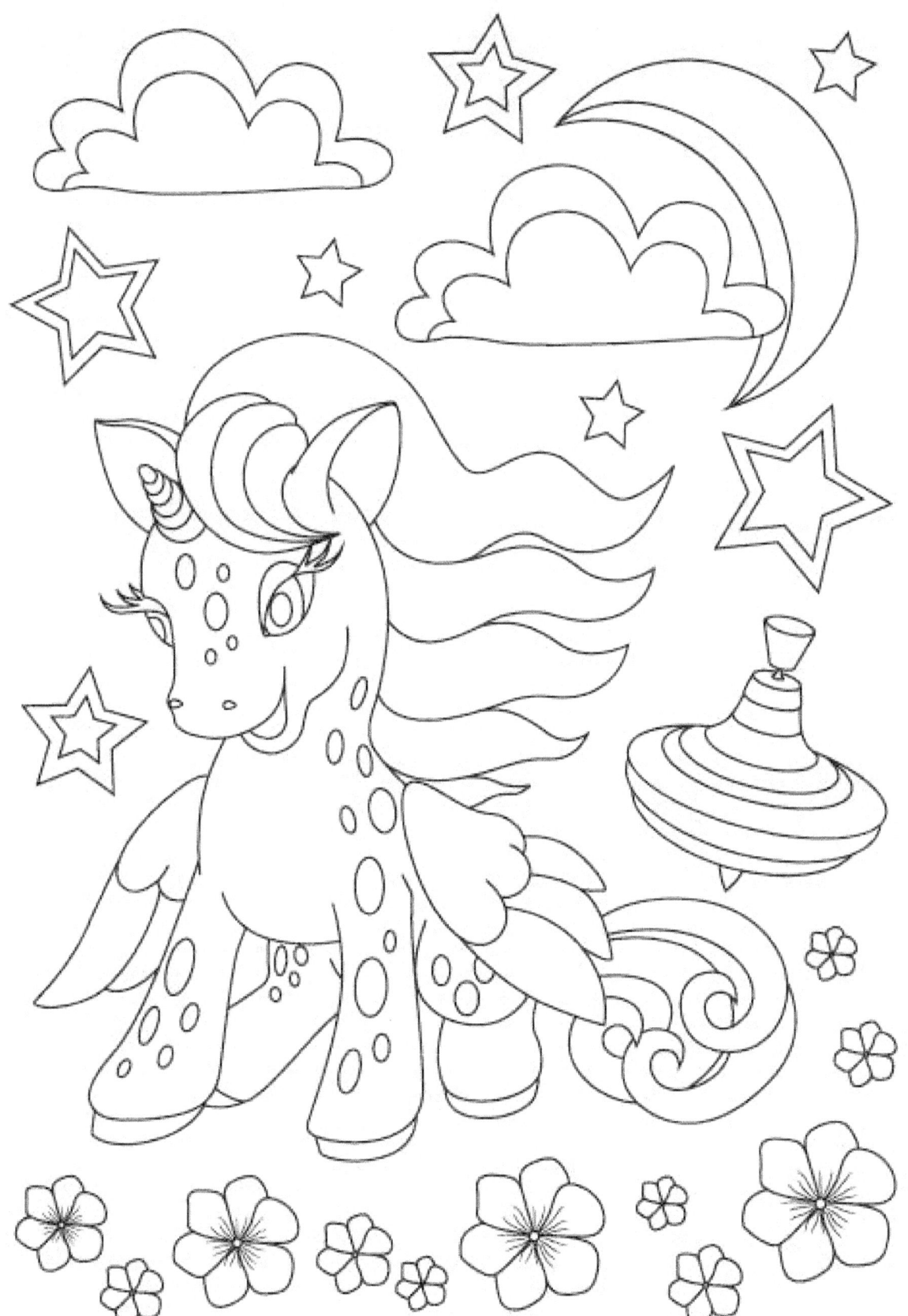

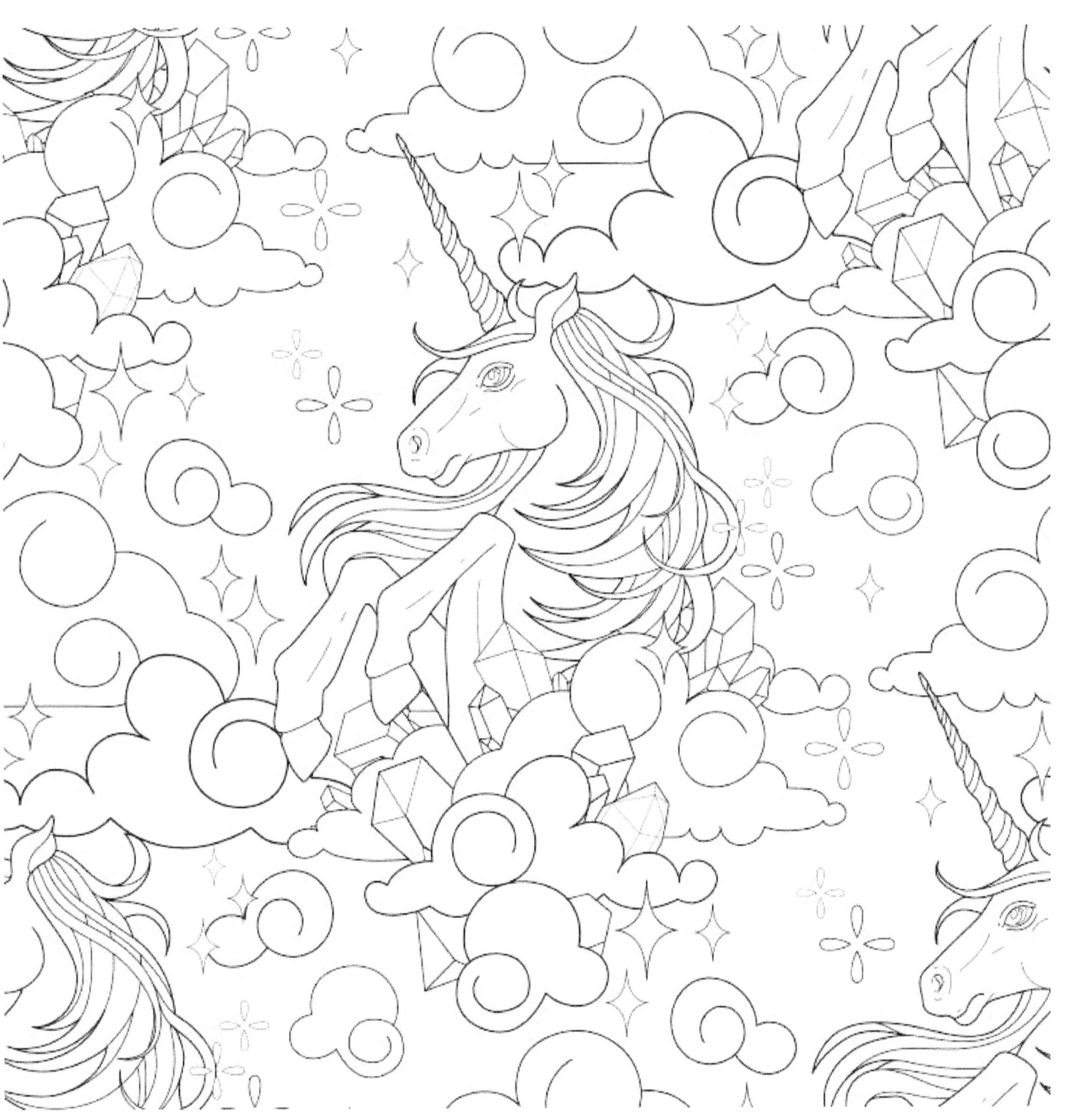

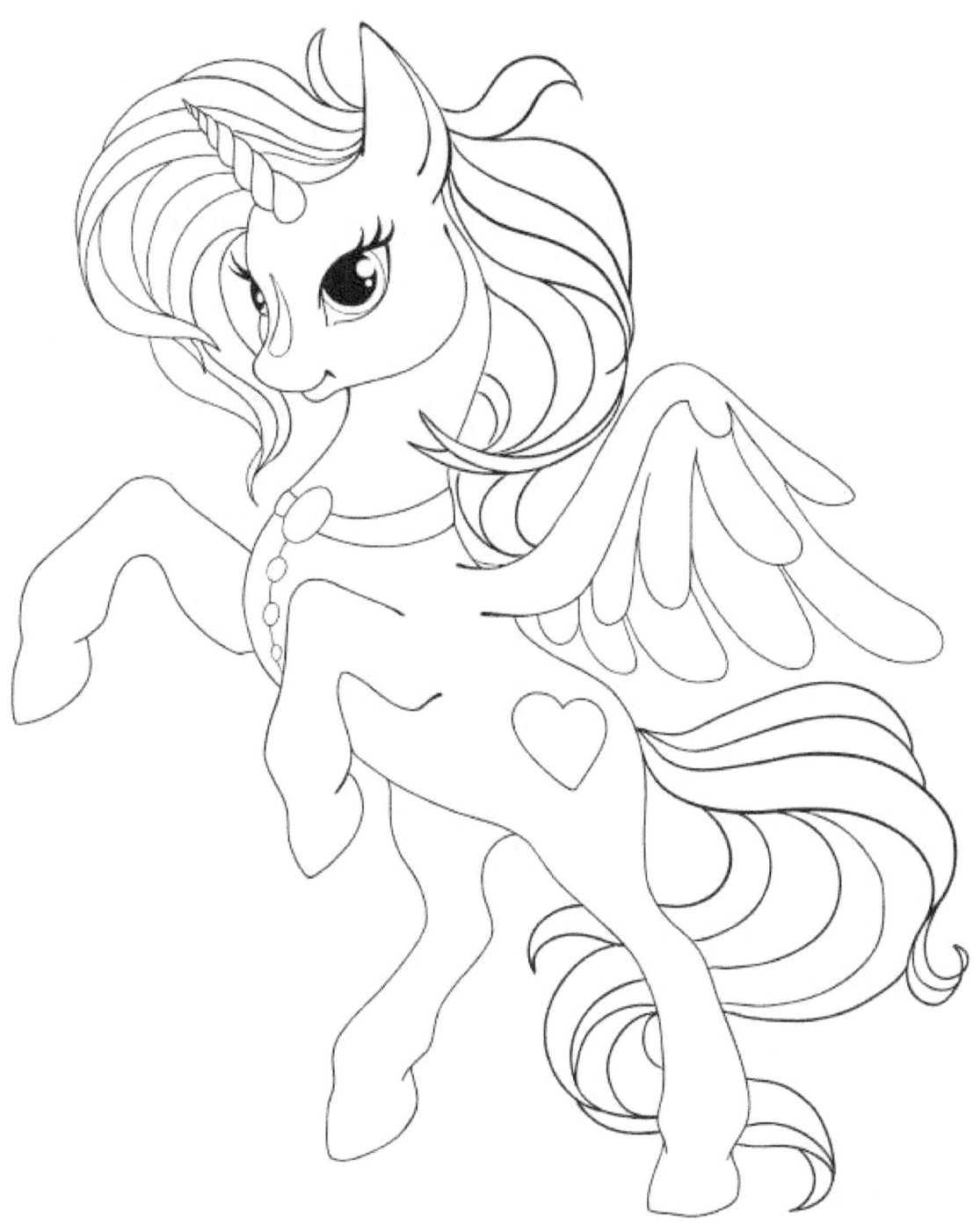

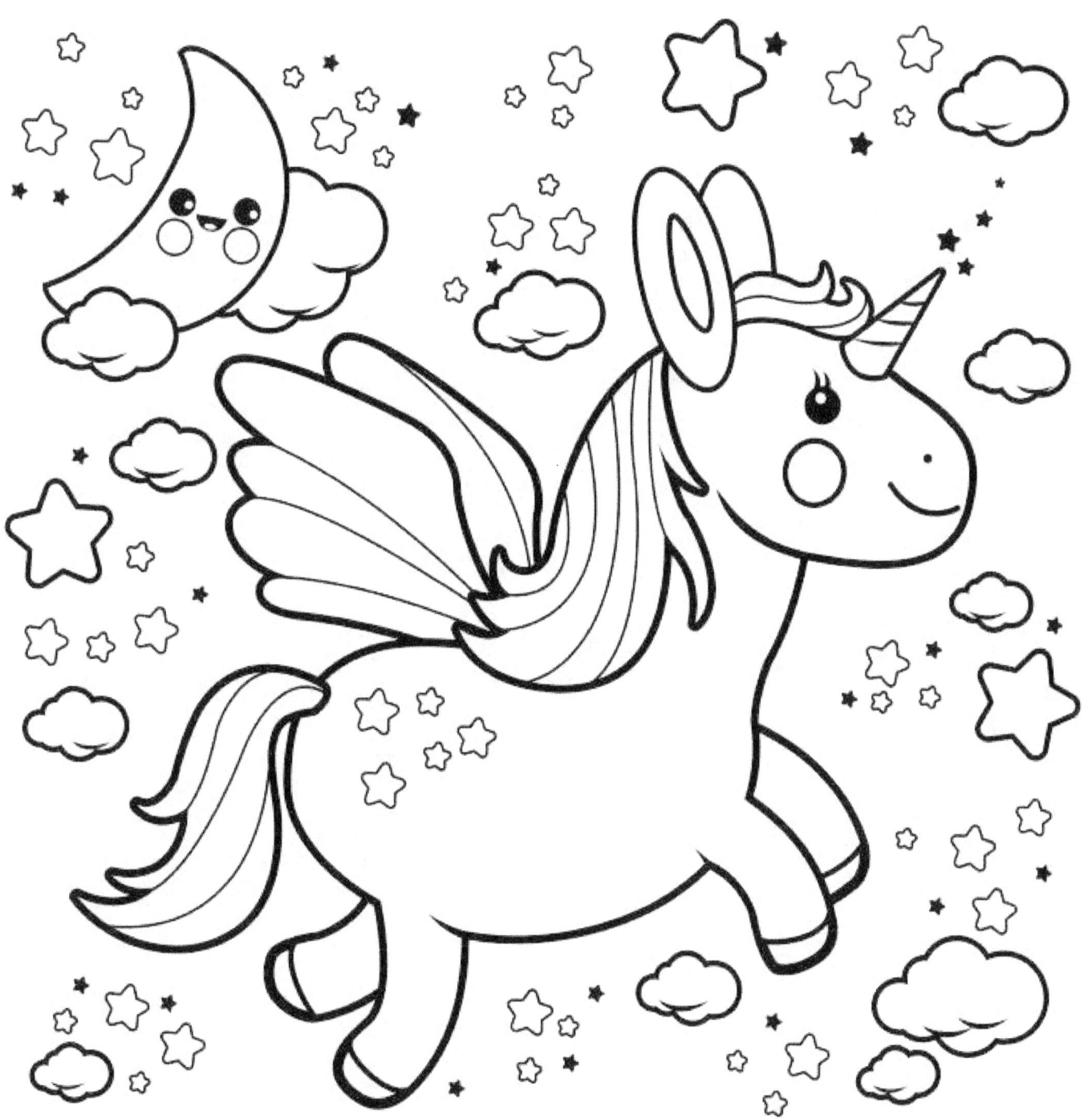

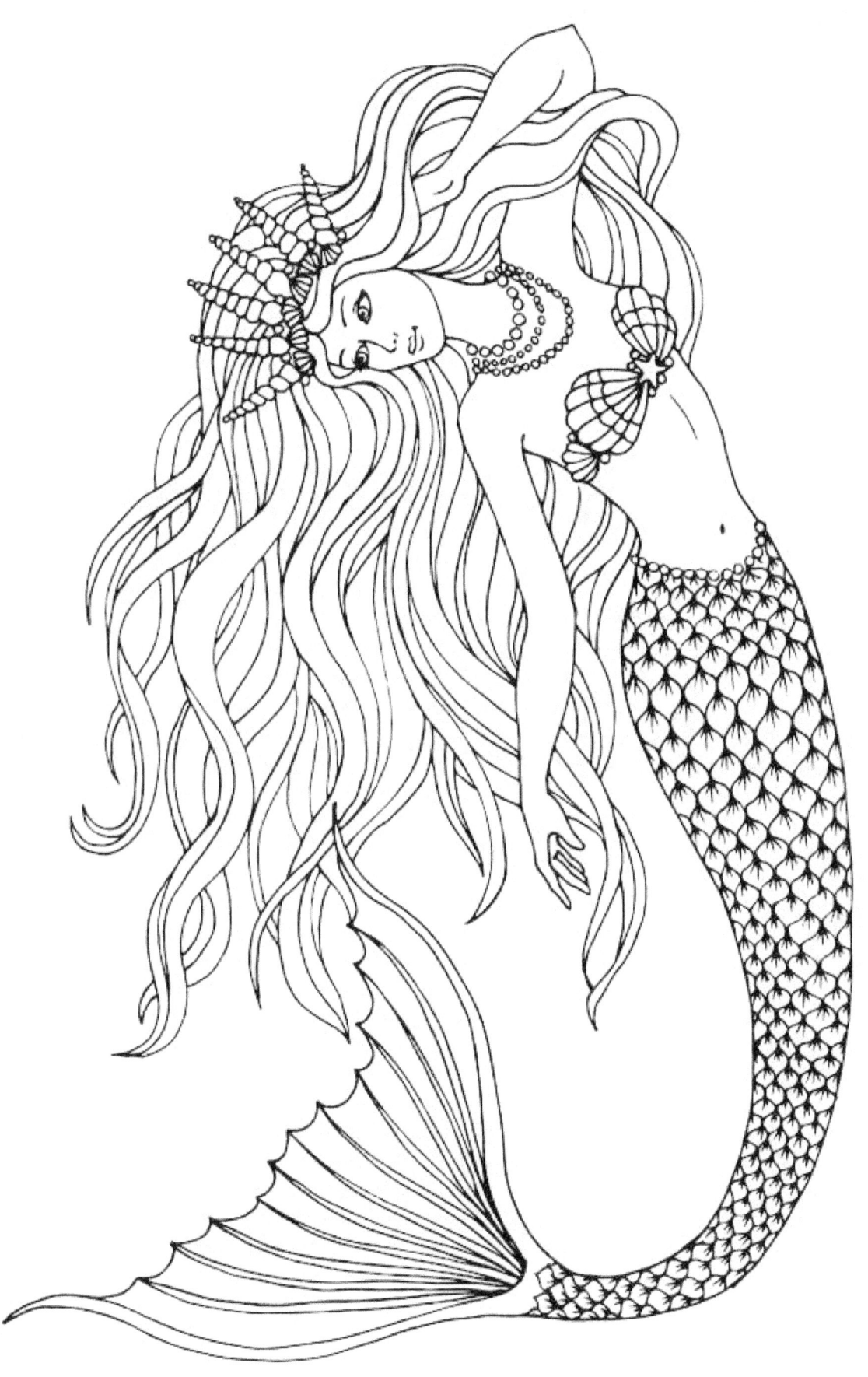

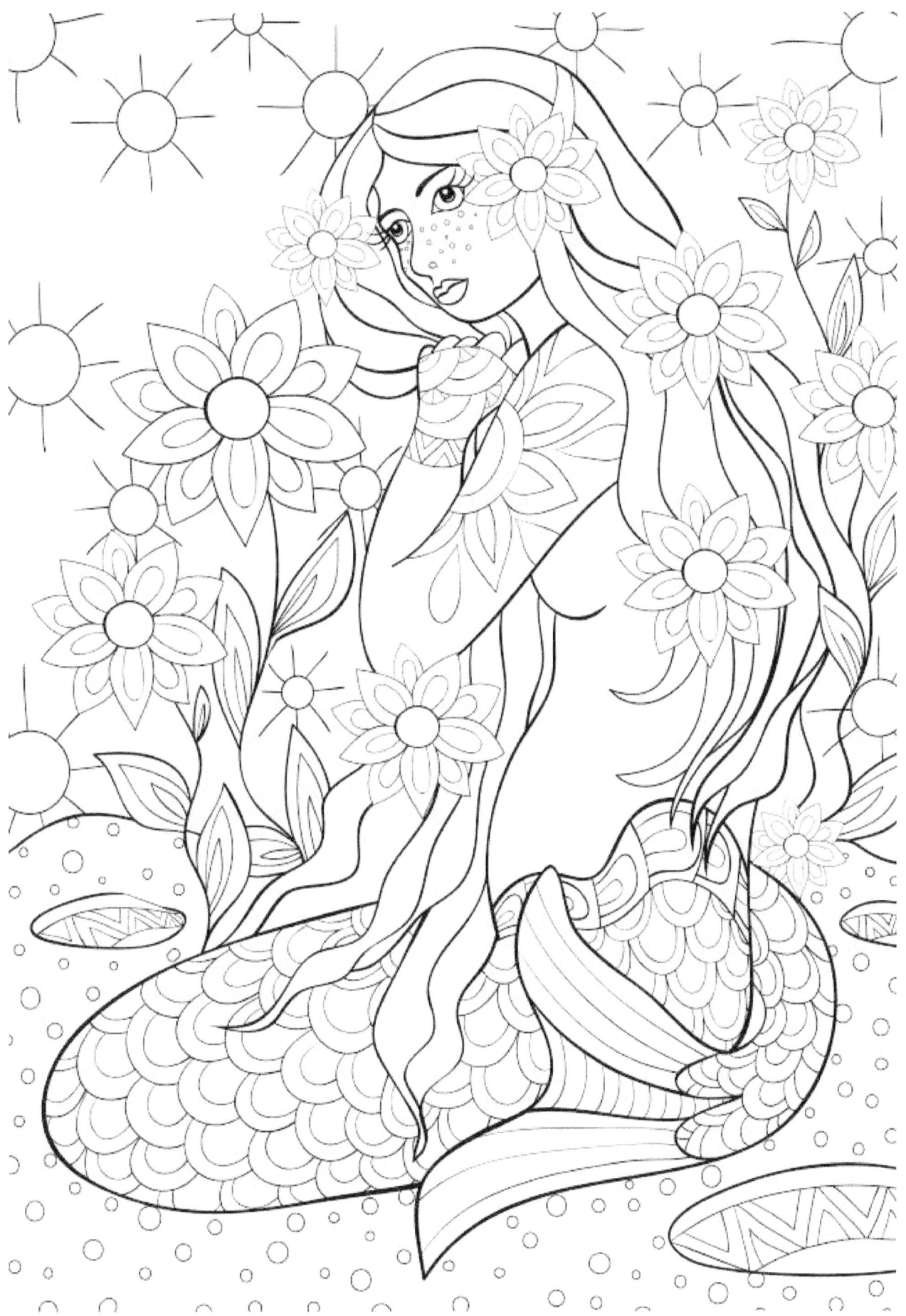

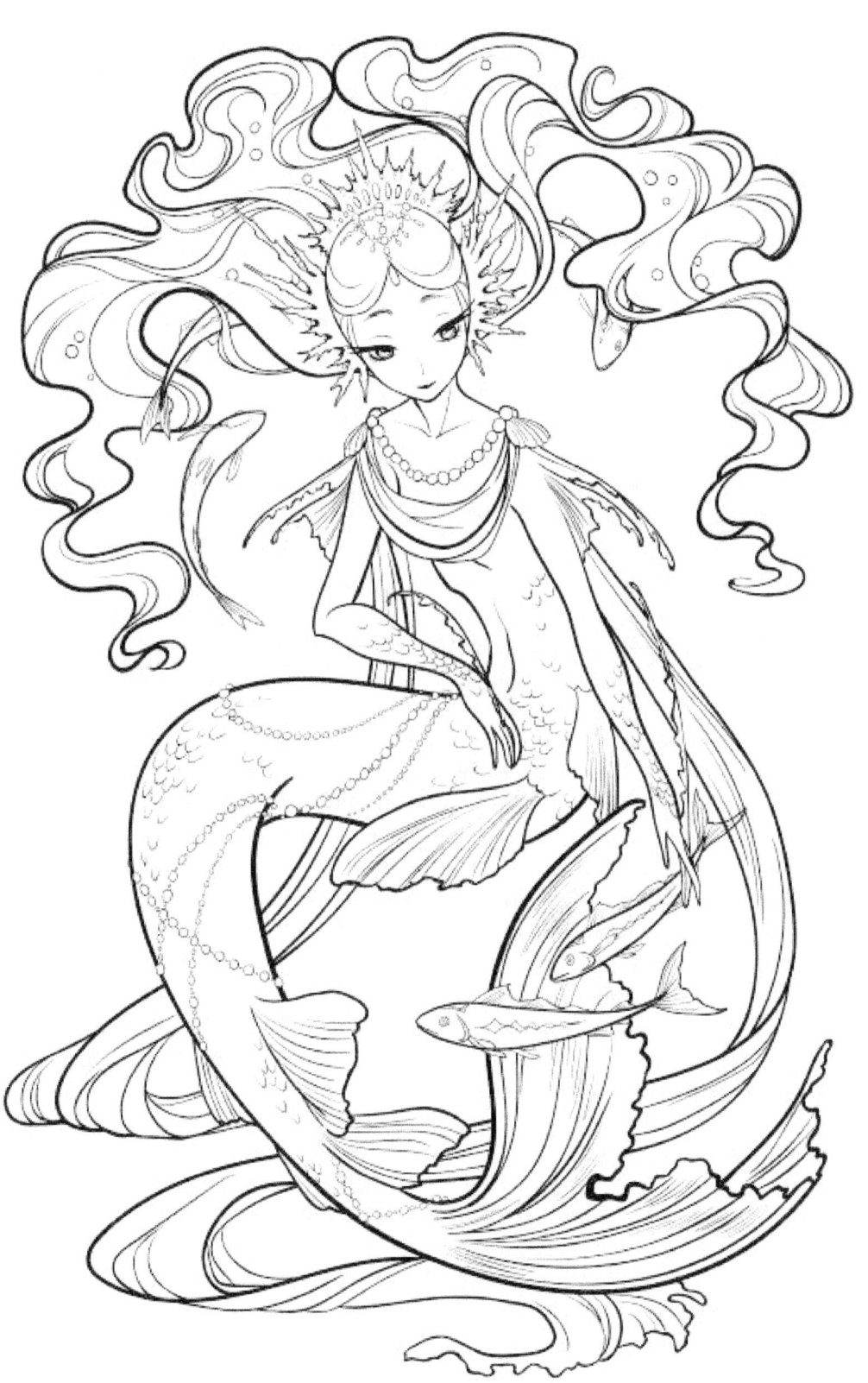

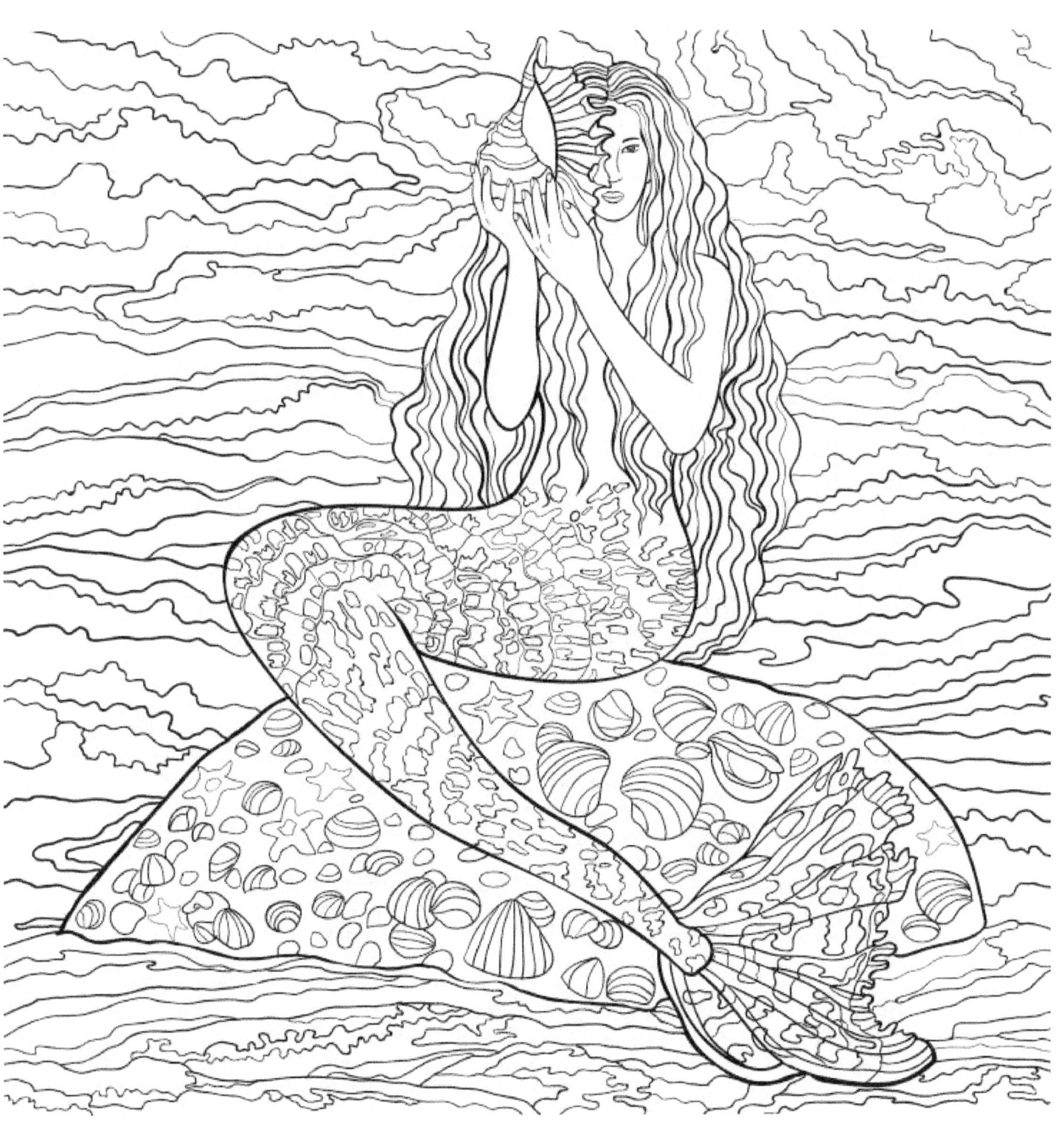

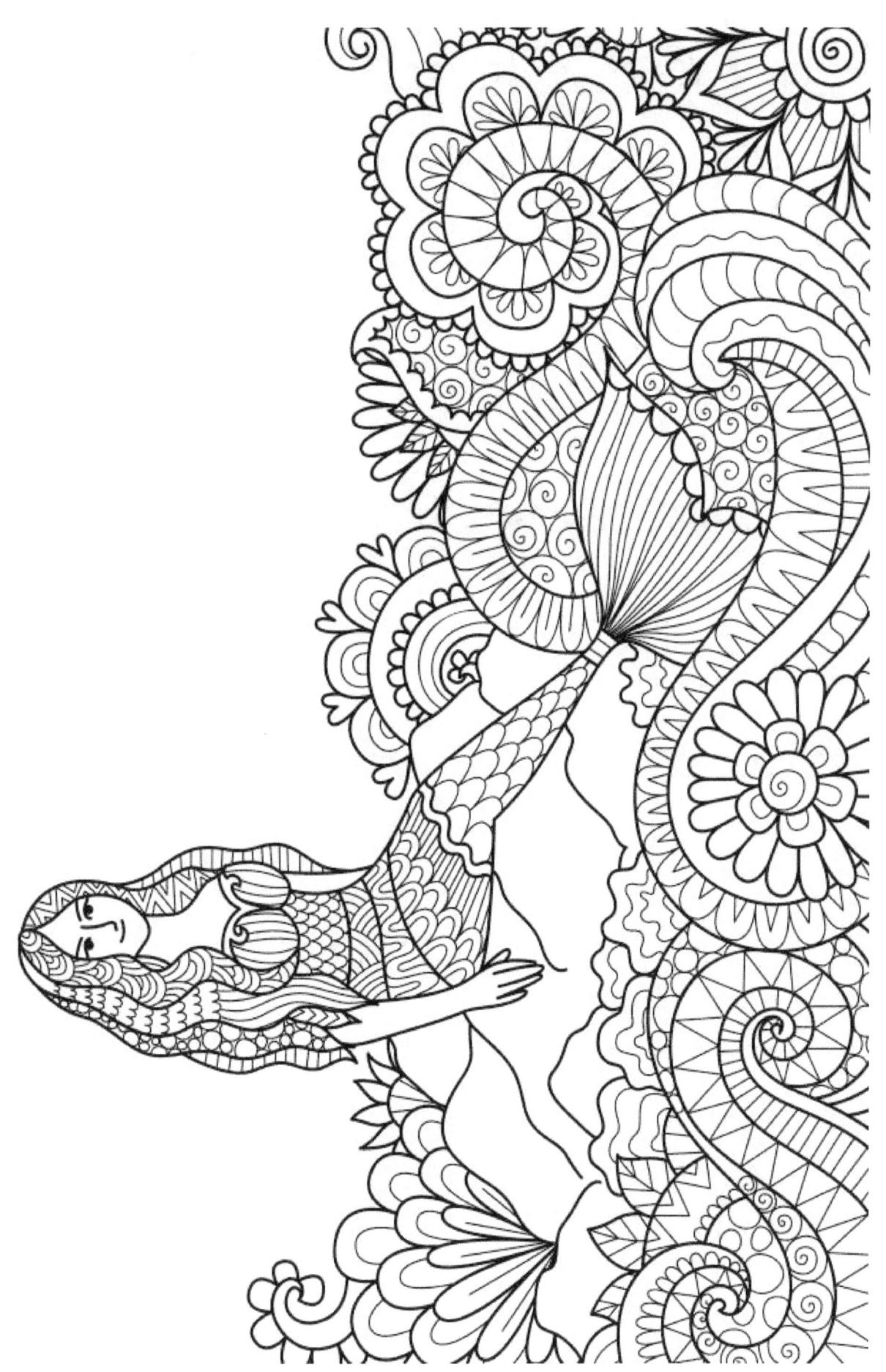

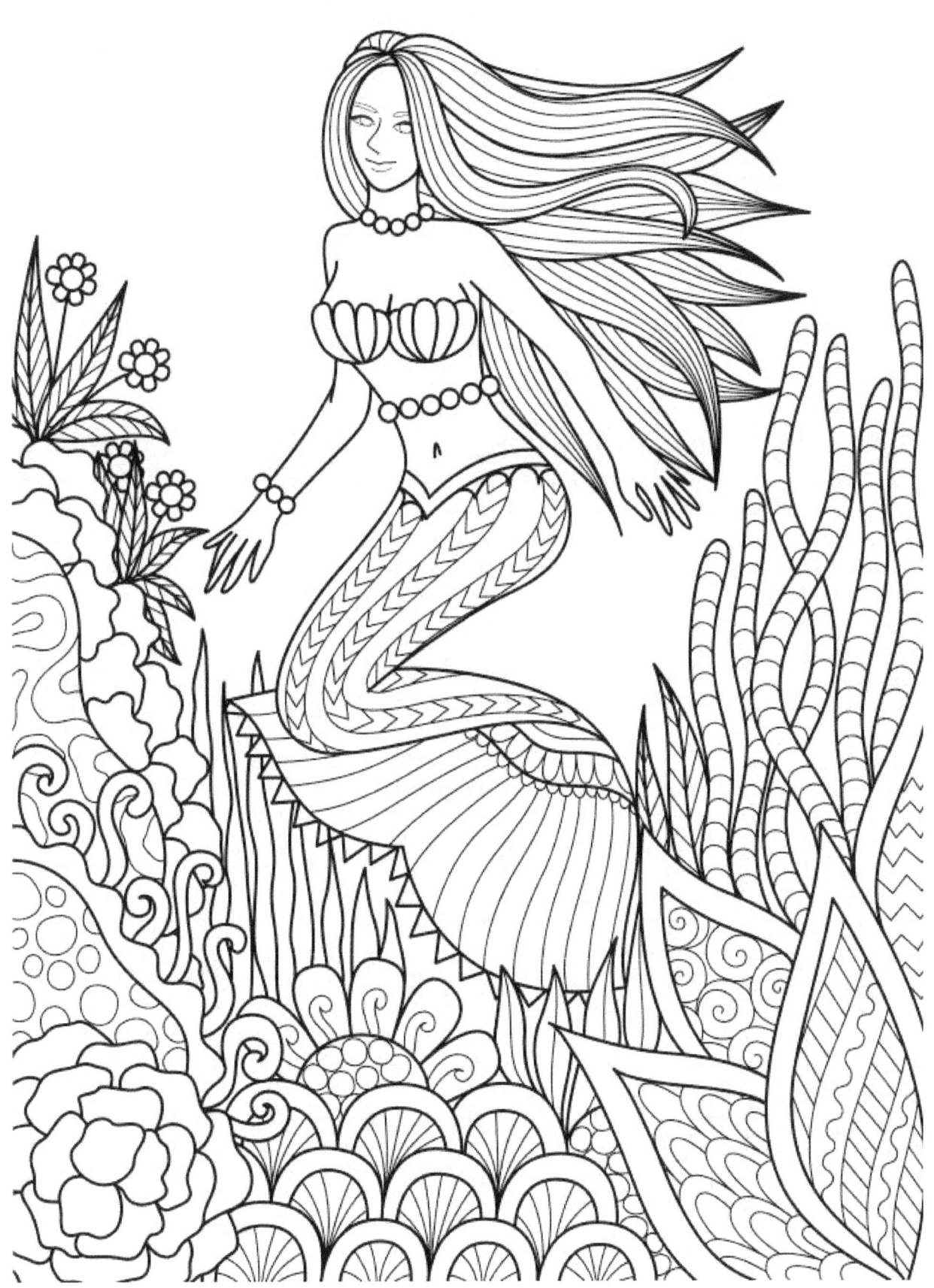

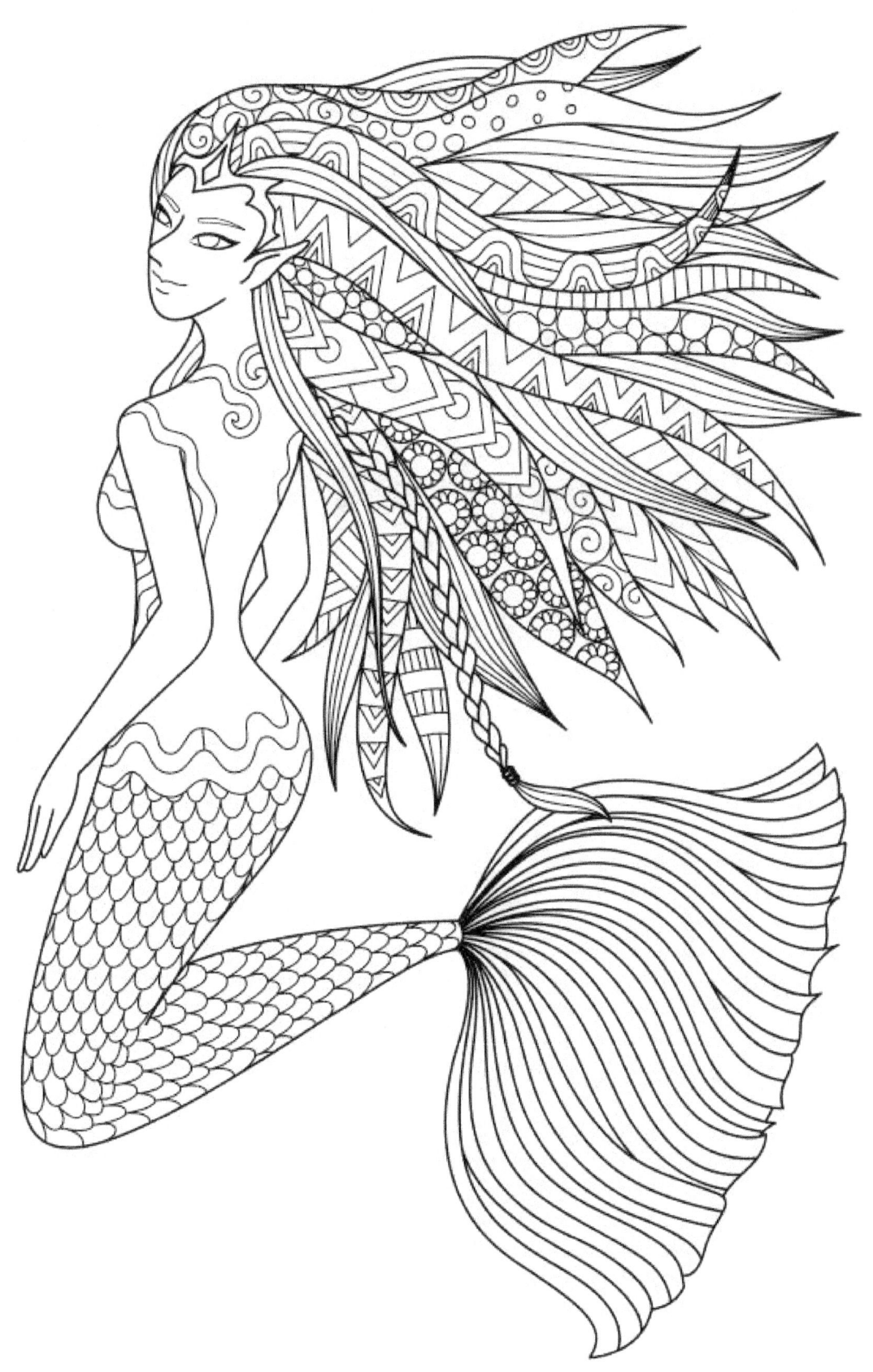

www.ingramcontent.com/pod-product-compliance
Lightning Source LLC
Chambersburg PA
CBHW081014170526
45158CB00010B/3040